electroworks

Library of Congress Cataloging in Publication Data
McCray, Marilyn.
ELECTROWORKS
ISBN 0-935398-00-7 Clothbound
ISBN 0-935398-01-5 Paperback
Library of Congress Catalogue Card Number: 79-67569
Copyright © 1979 International Museum of Photography at
George Eastman House and Marilyn McCrày.
Printed in the U.S.A.

Preface

nice quote

Technology and art need not be strangers, nor at odds with one another. In our scientifically advanced society, technology has been used to enhance the human environment and spur the human spirit—not only in practical ways, but in humanistic ways as well: Electricity has transformed the performing arts by new lighting and sound capabilities; the camera has given birth to a new art form, and television has opened the worlds of art to millions; modern printing techniques have revolutionized art and made its treasures more accessible to more people, at less cost, than ever before.

Art produced through xerography and other copying processes is a natural extension of the marriage between art and technology. Much of the art work done with these processes has been experimental, but the artists using these processes recognize them as exciting new art forms. The copying machine has become a tool for the contemporary artist.

There is a widening interest in the creative use of the copying process as more and more people become aware of its versatility. Work is being exhibited in the United States and Europe, and museums have acquired prints for their permanent collections. It is our expectation that ELECTROWORKS will give a wider audience the opportunity to assess copy art while giving the artist broad exposure in this new art dimension.

Emerson wrote that "the true test of a civilization is not the census, nor the size of its cities, nor the crop it produces, but the kind of art the country turns out." As our post-industrial society heightens its use of technology, it is essential that we preserve humanistic traditions. Future generations will judge us not only by our scientific advances, but by our artistic advances as well.

We hope this exhibit will be a step in the right direction.

C. Peter McColough, Chairman of the Board and
Chief Executive Officer, Xerox Corporation

118. Evergon, (Untitled) for Canada
Portfolio, 1978.

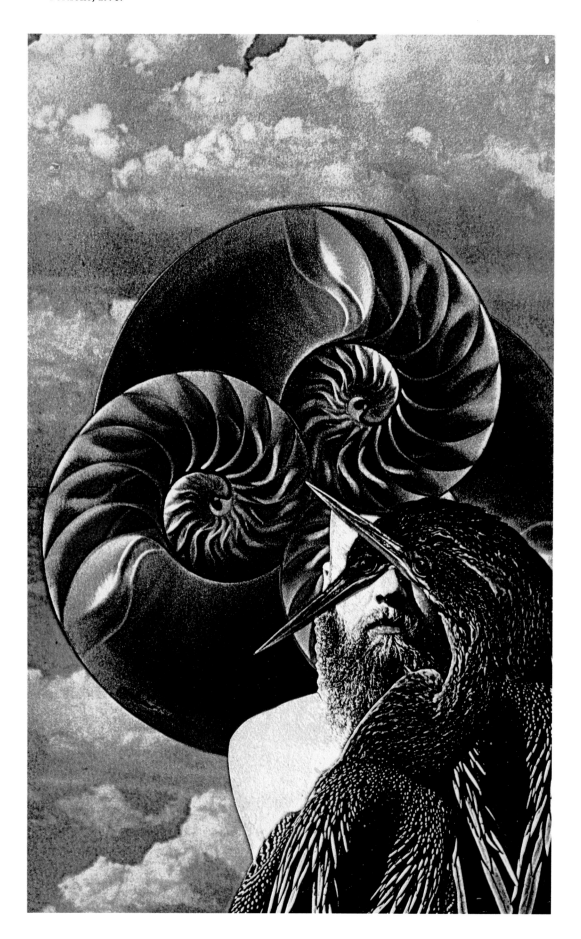

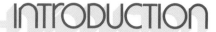

A new artistic medium invented by a patent attorney? If anyone had proposed such an idea to patent attorney Chester Carlson, the inventor of xerography, his reaction would have been one of amazement and probably disbelief. Carlson sincerely believed that the importance of his invention was confined to the realm of business communications and document copying, well outside the world of the experimental contemporary artist. The impact of copying machines and processes on the art of the seventies, however, is an important and widespread phenomenon. Artists have adopted copying machines—long regarded as banal, dutiful, office slaves—to develop personal aesthetic concepts and create original works of art. Ironically, new picture-making possibilities are discovered on machines which were primarily designed to mechanically reproduce office memos. Copier-media works of art have appearances that are the products of the scientific and engineering principles of the machines and that do not resemble paintings, drawings, prints, or photographs.

The Machines

In line with humanity's ongoing pursuit of the better mousetrap, copy machines and processes evolved from the practical necessity of improving printing technology by making the inexpensive reproduction of documents a practical reality. Hundreds of copying machines and processes have been marketed within the last century, ranging from the familiar silver photographic methods to those that use all manner of chemical reactions, heat, pressure, or static electricity. The first practical machine designed for use in the office was Thomas Alva Edison's Mimeograph. This process, which used specially prepared stencil masters for printing, was marketed in 1887 by A. B. Dick, a Chicago businessman who used the process in his lumber company to duplicate invoices and inventory sheets. The Mimeograph became so popular that A. B. Dick was soon no longer known as a lumber company but as a manufacturer of copy and duplicating machines. In the early years of the twentieth century, several gelatin-silver or conventional photographic processes that did not require stencils were introduced for copying. The Photostat, a French process of 1910, was by far the most popular, and is still used for copying legal documents such as birth certificates, marriage licenses, and deeds of title. The Photostat copy holds the same legal status as the original document.

The basic principles of several other methods of copying were discovered by a few independent inventors in the late thirties and early forties. In 1938 Chester Carlson, a young patent attorney in the New York office of the electronics firm P. R. Mallory and Company, made his first successful image with a process he called electrophotography (later called xerography—from the Greek, meaning dry writing). Carlson had become frustrated by the lack of carbon copies of patent specifications. After finding that no fast practical processes were available for making copies he began to work on devising a process of his own, one that used the optics of photography but formed direct positive images with static electricity, the same kind that causes clothing to cling on a dry day. In Carlson's process, a special metal or photoconductive surface is made sensitive to light by the application of an electrostatic charge; when an exposure of this photoconductive surface is made, it loses the charge in areas where the light strikes the plate. The latent image is then developed by dusting with a carbon-black powder called toner, which clings only to the charged areas of the image. This image is then transferred to a sheet of plain paper having the opposite electrostatic charge, and fixed with heat. Carlson's process was developed by the Haloid Company of Rochester, New York, which is now known as Xerox Corporation. Haloid had sold paper for other gelatin-silver copying processes before obtaining the rights to xerography. One variation on Carlson's process—direct electrostatic imaging—used a copy paper, coated with zinc oxide, that received both charge and toner. Developed by RCA (Radio Corporation of America), the process was marketed under the name Electrofax (electrostatic facsimile) and later under another name, VQC (Variable Quality Copier), by 3M Company (Minnesota Mining and Manufacturing).

During the winter of 1939–1940 Carl Miller, a graduate student in chemistry at the University of Minnesota, tired of the tedious, time-consuming process of copying long passages by hand from scientific texts for his dissertation, invented another copying process. Remembering that his father, a Canadian language professor and amateur photographer, had copied Hebrew lessons for his students photographically,[1] Miller began to photograph the material; to his dismay, this process was more time-consuming than before. He then began to experiment with a simple process that formed direct positive images with heat. Miller's process, called thermography (Greek for heat writing), was based on the principle that the typed black characters on the page absorb heat and the white paper reflects it. By using a treated, heat-sensitive paper placed in contact with the original document, a dry copy is made. The process was developed and later marketed in 1950 by 3M Company under the name Thermo-Fax (heat facsimile),[2] which was coined by Miller. Another process developed from this time, the Kodak Verifax, was the product of research carried out in the forties by two Eastman Kodak chemists, Dr. Harry Yutzy and Dr. Edward Yackel. This was a duplicating process that used a master or special matrix on which a negative image was formed, which was then transferred to treated copy paper. The resulting copy emerged damp, with an overall brown cast.

The commercialization of copying machines based on the principles discovered by Miller and Carlson began in the fifties. The white-collar world was undeniably changed by the introduction of machines like the Xerox 914. Mechanization of copy processes in the sixties

[1]Interview with Dr. Carl Miller, January 31, 1979, St. Paul, Minnesota.

[2]Letter to author from Dr. Carl Miller, not dated.

made the machines cheaper and more convenient. The copier became an ubiquitous fixture in the office landscape, as common as the telephone or the typewriter. An avalanche of paper soon followed as the machines seemed to stimulate the demand for themselves.

A multi-million-dollar industry grew out of the copier craze of the sixties. Machines now manufactured by numerous large and small corporations have evolved into highly complex automated systems that could rival the creations of even the most imaginative science-fiction writer. Engineered to produce predictably uniform prints even when used by an untrained operator, these robot-like machines have become the ultimate realization of the "you-push-the-button-we-do-the-rest" prophecy of photography and contemporary art and are automated to such a degree that copiers will print for only a dime. The popularity of copiers has spread so rapidly that the machines have become an integral part of daily life and can be found not only in offices, but in such diverse settings as libraries, schools, post offices, supermarkets, laundromats, and drugstores. Brand names of copiers are now firmly established in the contemporary vocabulary and, in fact—much to the dismay of many manufacturers—have become generically used nouns and verbs. This genericizing of trademarks began with the Mimeograph, and almost everyone knows the phrase "to Xerox"—Xerox Corporation's name has become almost synonymous with the act of copying, even when done on a competitor's equipment.

Copy capabilities were expanded in the late fifties, when colored toners were first added to the RCA Electrofax process on an experimental basis. Seven color toners were developed for xerography by Haloid for Walt Disney Studios. Animators at Disney used the copiers and color toners to speed the process of making the thousands of cels, or drawings, required to create movement in a single cartoon character. One of the first films made by Disney to be produced with copier techniques was "One Hundred and One Dalmatians." Animation studios still use color copiers in the production of cartoons for Saturday-morning television.

3M Company introduced the automated Color-in-Color copier at its 1968 annual stock-holders' meeting. As its name suggests, the system reproduced color originals in full color. Invented by a team of engineers headed by Dr. Douglas Dybvig, Color-in-Color formed images with a direct electrostatic process that was coupled with a thermal dye-transfer system. The dry color print was created within sixty seconds. Of the six color copy systems, from manufacturers in Japan, Australia, and the United States, the only other color process to reach the marketplace was the Xerox 6500 Color Copier. The Xerox 6500 uses existing Xerox copier systems but employs color toners, much like the ones developed for Disney. Both the 3M and the Xerox color systems use the principle of subtractive color with automatic filtration for separation, and the basic three process colors: yellow, magenta (red-purple), and cyan (blue-green). These process colors are the same colors used in color photography and color printing.

The Artist and the Machine

Once the business community had embraced copy machines as the way to speed communications and increase efficiency, office workers began to discover these machines; frequently, the images produced by file clerks and other office staff were unbusinesslike. Then artists discovered the pictorial capability of the machines when a detail of a hand or sleeve inadvertently appeared on the copy of a book page or letter. Playfulness coupled with curiosity about the machine and its inherent possibilities for image manipulation stimulated those artists who were seeking new picture-making processes. Artists from widely diverse backgrounds began to combine personal perspectives with the novel qualities of each machine or process. The universal availability of copiers contributed to the proliferation of this artistic phenomenon.

In the early sixties, artists began to work with copy machines, whether located in offices or installed in public places. For these artists, copiers were truly "found media," personal discoveries uncovered in settings not previously recognized as associated with art-making activities. N'ima Leveton, a San Francisco printmaker, produced her first series of prints on a coin-operated machine in her neighborhood supermarket. In 1964, Barbara Smith leased a Xerox 914 copier, which was installed in her dining room; her family ate elsewhere while she worked on the machine. Esta Nesbitt discovered the office copier at the Parsons School of Design, where she was a faculty member. Nesbitt continued the work she had begun at Parsons on the machines in the Xerox showroom in Manhattan, arranging her work schedule around sales demonstrations. These settings were unlikely places to find artists working. While not as romantic as the nineteenth-century notion of the artist laboring in the obscurity of the garret, the effect was the same—the artist was in an isolated environment, away from other artists.

Artists were generally not aware of other artists who were working with copiers. Each artist's work, therefore, was intensely personal due to the lack of communication between artists. There were no shared motifs or sensibilities. Artists evolved special vocabularies of images and bodies of work oriented around the specific functions of each machine. No art-historical precedents were available to early copier artists; parallel trends developed, however, as unrelated artists simultaneously explored and experimented with similar approaches, stylistic conventions, and techniques. The democratic access to equipment makes it impossible to assign an accurate priority of invention for style or subject matter.

In fact, it is impossible even to answer the question of who were the first artists to consider the copier as a creative tool.

Copier artists do not comprise any single cohesive group, school, or movement in the art-historical traditions of the "isms" from past decades. No copier manifestos exist to define an all-pervasive, shared artistic sensibility. There are no regular meetings or large-scale group activities within copier art like previous art/technology organizations such as EAT (Experiments in Art and Technology), a group of artists, scientists, and engineers who, during the sixties, met regularly to discuss collaborations and large public performances that combined the sensibilities of both art and science. Copier art is still a closed partnership between the artist and the machine.

The history of the partnership between the artist and the copier is a short one, less than twenty years, and the progressive awareness of other artists and stylistic trends is only a recent occurrence; copier artists do, however, share a common attitude toward copier and communication processes as expressive, legitimate media. Public awareness of copier art did not begin until the early seventies, after a small number of one-person and regional exhibitions.

Artists have combined copier aesthetics with perspectives from almost every current field of artistic endeavor, including painting, design, sculpture, ceramics, printmaking, photography, video, film, animation, conceptual art, performance, poetry, artists' books, correspondence art, and industrial graphic arts. Artists have used copiers as tools with which to define individual bodies of work or have applied the aesthetics and pictorial sensibilities developed in other media to make new work. These artists, who have already created extensive bodies of work, find that copiers offer new solutions to formal relationships or permit the translation of existing motifs into new materials; Robert Heinecken, for example, known for his photography and printmaking, adapted the synthetic color spectrum of the 3M Color-in-Color system to his personal iconography in one series of lithographs and etchings. Other artists have chosen to work exclusively with copiers and have developed new categories within the artistic discipline derived from their experiences with the machine. Sonia Sheridan founded the Generative Systems Department at the School of the Art Institute of Chicago after her extensive investigations with copiers and communications equipment.

Copiers have substantially changed the nature of the creative process and the way in which the artist works. Many aspects of artmaking have been tied to the physical dimensions of the machines. The static and bulky nature of most copier equipment requires that the copier artist make pictures in the arena of the machine and that the raw materials—objects, images, ideas, and models—must be brought to the machine. This approach most closely approximates that of a printmaker, as Robert Rauschenberg or Eduardo Paolozzi, who also bring images from newspapers, magazines, and advertisements into the studio to compose images on printing plates. Copier works are therefore the products of an artist-created world in which details are excerpted from settings in the external world and in which it is impossible to recreate the expansive landscapes of the "eloquent light" philosophy of Ansel Adams.

Artists developed a new repertory of methods and a new hierarchy of subjects that were specifically suited to the ideation or definition of this new medium. The resulting prints are the products of interpretation by both artist and machine. Pati Hill, author and artist, describes the nature of this partnership:

This stocky, unrevealing box stands 3 ft. high without stockings or feet and lights up like a Xmas tree no matter what I show it.

It repeats my words perfectly as many times as I ask it to, but when I show it a hair curler it hands me back a space ship, and when I show it the inside of a straw hat it describes the eerie joys of a descent into a volcano.[3]

[3]Announcement of Pati Hill exhibition, *Common Alphabet #1*, Franklin Furnace, New York, November 21–December 8, 1979.

Other physical limitations of the processes affect the characteristics of the prints. Sizes of paper, software and processing machines have all been standardized by manufacturers to meet office requirements. The dimensions of the document glass or platen on an automated machine on which the artist composes have been established by the requirements of business. Legal- and letter-size prints are one unique hallmark of copier media. A Canadian artist who calls himself Evergon has said, "It becomes a game trying to compose and fill the elongated 'legal' space."[4] These sizes differ from the standard sizes in photographic materials and in traditional Western European art. Artists must give consideration to these basic sizes by either composing within the given dimensions, as Evergon does, or by considering these business sizes as components for larger works.

[4]Interview with Evergon, February 18, 1979, Rochester, New York.

The rapid printout systems of automated copiers have provided the artist with a spontaneity or instant gratification that is paralleled only by the use of another electronic medium, such as video. Copier systems are capable of producing dry prints within seconds, placing the artist on a real-time basis in which ideas and pictorial problems can be resolved without

going through the tedious labor that is involved in other art processes. No time is wasted between the conception of an image and the resulting print. The artist is provided with material almost immediately; more of the creative process is involved with evaluation and selection. In the words of Sonia Sheridan, "Think it—Have it."[5]

Each copier manufacturer's process possesses specific characteristics that are unique to that process and artists will seek out a particular machine for its inherent visual qualities. Pati Hill, for example, prefers the solid black matte produced by the IBM Copier II. When she uses another copier, she usually applies a spray fixative to change the surface of the print so that it appears more like that of the IBM. She has thus developed a personal aesthetic around one manufacturer's process.

Systems designed to reproduce line copy or typed characters produce only a ghostly halo effect in solid areas. Bruno Munari, the Italian artist and designer, favors this effect in many of his prints done on the Xerox 914 copier. Continuous-tone processes produce images that look different than the gelatin-silver photographic print. The images are higher in contrast and have the distinctive surface texture that results from the patterns formed by static electricity and the evenly distributed toner. Coated paper copiers yield yet another surface texture, which is velvety. Sonia Sheridan prefers the 3M VQC, a coated paper zinc oxide system that gives rich, lustrous blacks.

Color copiers have provided the artist with the ability to use color in the same instantaneous basis as that provided by machines that copy in black-and-white. Color systems such as the Xerox 6500 and the 3M Color-in-Color provide the artist with the limited palette composed of the three primary process colors given earlier—yellow, magenta, and cyan. The chromatic range has been industrially determined to provide a somewhat limited color capacity, termed functional color.[6] Functional color systems do not provide the realistic natural color found in systems that have pictorial[7] capabilities. Color photographic materials and four-color lithography are pictorial systems that are more faithful to nature. The scientists who developed the color copiers did not use nature as the standard by which their color systems were judged; instead, they sought to match the color qualities found in color photographic prints. Scientists from 3M used photographs of Dr. Dybvig's children as their basis for comparison.[8] The limitations of the copier materials, coupled with the chromatic insensitivity of the photoconductive material and the color components in each system, determine the distinctive color qualities peculiar to each machine. These limitations in the color fidelity were not considered drawbacks by the manufacturers because the color copiers were intended to reproduce solid areas of color on graphs and sales charts.

Copier color is expressive, not imitative. The Xerox 6500 Color Copier uses pigments of the three primary process colors to create functional color. The pigments are related to those found in some paints; when coupled with the polymer resin of the toner, they produce a filmy layer of color. This kind of color closely approximates the appearance of acrylic paint, a medium favored by many contemporary painters. The color qualities are synthetic, luminous, and vivid. The system reproduces bright colors more accurately and favors those chromatic ranges found in other artist materials, such as felt markers, pens, and crayons. Images produced on the Xerox 6500 are highly detailed. The 3M Color-in-Color system creates color with the same basic process primaries, from donor sheets impregnated with thermally activated dye. The color is saturated and brilliant and the prints have a velvety tactile surface from the texture of the paper, which receives the dye. Details are suppressed and the edges of shapes are softened in 3M prints.

The limitations of color copiers are not considered to be disadvantages by artists. Subject matter is frequently selected to favor the limited chromatic range of the process; an intensely enhanced color image results. California printmaker Erin Goodwin chose fabric and a specific kind of colored egg for her Magicians Series. The prints demonstrate the optimum relationship between the subject and the Xerox 6500 process, and show a clarity of color that continues to amaze the inventors of the system. The mechanical controls of the copiers also allow the artist to make selection of color compositions from dry prints. Using the 3M Color-in-Color Bill Harris found that he could make over one hundred variations of his NASA/Tibetan Mystic collages in just one hour. This permitted him to experiment with color in a way that is not possible with color photography or printing.

Copier systems and other technological processes have produced repercussions in the arts, where technology is viewed as rational, inhuman, and therefore not creative. The very qualities that attract artists to copy machines have provided major stumbling blocks for "old-line" humanists and art-for-art's sake critics;[9] in one 1971 New York Times review of an exhibition Hilton Kramer said that he found the copy machines in the gallery more interesting than the works of art on the wall.[10] Questions about the legitimacy of automated business machines and industrially developed processes as works of art continue to be addressed by critics, if not by artists. This is not a new issue, or one which has been specifically confined to copier art. In reference to another mechanical picture-making process—photography—the French poet Charles Baudelaire wrote in 1859 that "Industry by invading the territories of art has become art's most mortal enemy,"[11] a view held by

[5]Interview with Sonia Sheridan, May 30, 1978, Chicago, Illinois. Also published in Gottlieb, Martin, "Copier Art Art Art Art," New York Sunday News, September 29, 1974.

[6]Interview with Peter Waasdorp, Xerox Corporation, April 2, 1979, Rochester, New York. Functional color is a term used in the copy machine industry to define the specific color capabilities available with copy machines.

[7]Interview with Peter Waasdorp, Xerox Corporation, April 2, 1979, Rochester, New York. Pictorial color is a term used in the copy machine industry to identify the mechanical reproduction of color systems, which are capable of rendering a more complete tonal and hue range than are functional systems.

[8]Interview with Dr. Douglas Dybvig, 3M Company, February 1, 1979, St. Paul, Minnesota.

[9]This term was coined by Douglas Davis in "Art and Technology: The New Combine," Art in America, January/February 1968.

[10]Kramer, Hilton, "Reviews," New York Times, December 4, 1971.

[11]Baudelaire, Charles, The Mirror of Art; Critical Studies. Phaidon Press, London 1955.

many critics, in spite of the large number of industrial processes and materials now used in painting, sculpture, and other art forms. The double stigma of business origin and subsequent automation is further complicated by the fact that the very same machines used to reproduce office memos are also used to create works of art. The same machine in a copy center is used both by the artist and by the office worker without any adaptation or modification. No differentiation is made between the basic business function and the specialized function of making art. The idea that a work of art could be created just by pushing a button demands that a distinction be made between the fine artist and the lay "Key Operator." Mechanical tools have long been regarded by some as the preserve of the unskilled; this is further underscored by advertising copy that proclaims, "anyone can make perfect copies anytime."[12]

[12]Advertisement for the Xerox 914 Copier.

Questions of which contributed more to the work of art—the artist or the machine—seem inevitably linked to copier works by the same humanist critics, who still find it difficult to believe that a mechanical system could produce works of art that are unique, personal, and of aesthetic value. These critics still long for the mark of the human hand before they can certify an artwork as an artwork, or label a process as art. "New-Line" critics like Douglas Davis, however, hold a different opinion. Writing on art and technology in 1968, Davis said:

Living as they do, in a supertechnological society, . . . artists have quite naturally turned to the products, processes and imagery of science and industry. Some approach technology with traditional attitudes, others are using it to alter the very definition of art, but all who succumb to its fascination have responded with a new sense of exhilaration and discovery.[13]

[13]D. Davis, "Art and Technology," *Art in America,* 1968, 29.

The development of copy machines as an artistic medium represents a unique incidence of industry applied to art, which has given rise to a new definition of art.[14]

[14]This concept was communicated to me by Robert A. Sobieszek, October 1, 1979.

Although called copies, copier prints are not reproductions of other works of art or substitutes for the "real thing." They are conceived as unique objects, even though produced with a system that was designed to embody the application of the many-of-a-kind concept. The ten-cent copy becomes a work of art when it is assigned new roles and shifted from its utilitarian, information-transmitting function. Connotations are assigned by the artist to emphasize aesthetic merit and exhibition value. The German-Jewish essayist and critic Walter Benjamin has described this shift in function as occurring when a photograph of a family ancestor that is no longer important as a cult object connected to the family is later given exhibition value. Copier prints have definitely undergone such a shift.

The idea that a copying process is at odds with the standards of creativity has long been a truism in the fine arts. Ruskin in 1857 warned against the chicanery and debasement of copying with the statement "Never buy a copy of a painting."[15] The mechanical copying process would seem to embody a curious paradox in the context of fine arts, where so much emphasis is placed on qualities of authenticity and originality.

[15]Quoted in Brookes, John, "Xerox Xerox Xerox Xerox," *The New Yorker,* April 1967, 46.

Unlike artists from the past ages, contemporary artists seem to have no horror of copying—and, in fact, Andy Warhol and the Pop artists copied the industrial products of the sixties, because they were no longer concerned with proving the definition of creativity. Copier artists are not concerned with proving their creative powers or addressing either the traditional definitions of copying or creativity. They have accepted a process that embodies one of contemporary art's most curious paradoxes—mechanical processes designed for copying but used to create. Douglas Davis described an attitude now taken by copier artists:

The machine is endowing art with an element of play—play in the sense of scope and freedom, play in the sense of sheer fun. The NEW COMBINE (of art and technology) may outrage the old line humanists and the art-for-art's sake critic, but today's artist rushes forward in his new partnership with technology, leaving foes and critics behind.[16]

[16]D. Davis, "Art and Technology," *Art in America,* 1968, 46.

The artists in this exhibition have acknowledged that partnership between artist and machine. Unique issues have developed as the picture-making possibilities inherent in each copy process have been used. The artists included in ELECTROWORKS represent only a small number of those who are actively involved with copier processes; many of the names will not be familiar. This exhibition will focus on the development of style and attitude by artists who have adopted these business machines as expressive tools.

27. Bruno Munari, Original Xerography,
 1977.

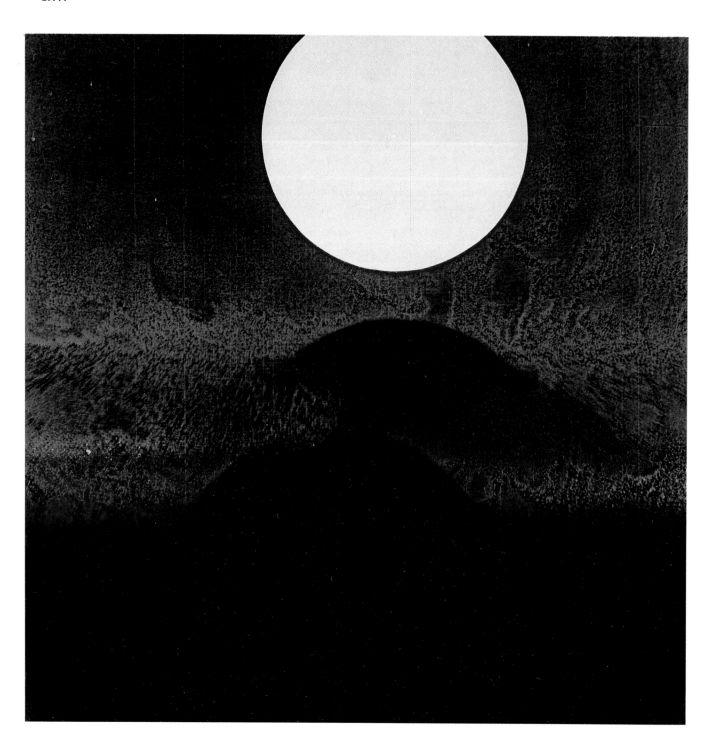

As artists began to interact with copiers, several individuals developed parallel attitudes about the role of these machines in the arts. The artists, from widely diverse areas of interest, shared a curiosity about the functions of the processes and sought to develop artistic uses for communications technology. These artists have been placed in the category Generation One, not on the basis of age or length of involvement with copiers but because each artist has maintained long productive relationships with inventors, scientists, and manufacturers of equipment. They are one step removed from industry and the nature of each relationship affects the way in which the artist works as well as kinds of images produced.

Generation One artists approached copiers in order to define the art-making potential inherent in the various systems and processes. No previously defined genres of subject matter or methods of working existed and these artists sought to develop personal concepts by investigating the functions and properties of each machine. Through experiments and empirical visual research each artist began to define a body of work peculiar to copiers. Italian artist and industrial designer Bruno Munari discovered that he could use the machine like a pencil for a new type of drawing. He found that the slit scan shutter in automated copiers like the Xerox 914 could produce a predictable kind of distortion when the original on the platen glass was moved during the printing cycle. He used the slit shutter distortions to provide the illusion of speed for images of motorcycles and racing cars. Esta Nesbitt found that images could be made without an original document or subject on the machine's platen. By manipulating a reflective material over the platen, Nesbitt created images by directing the copier's own light back into the lens. The prints record gestural sweeps of light and were called Transcapsas by Nesbitt. She coined the term in an effort to describe the copier's ability to transform and encapsulate her ideas. Sonia Sheridan's investigations of copier and communications equipment are wide ranging. She does not place limits on her experiments and often works only with the software for a process outside the machine. She frequently combines the toners, sensitized papers, and machines from many processes to create a series of images. In Hand with Hearts, 1970, she addresses the unique process of image disintegration which happens when copies of copies are made. This sequential group of 3M Color-in-Color prints documents the occurrence of that process. In effect the process has become the subject for the artist's experiments.

Sheridan, Nesbitt, Munari and some of the other Generation One artists often create prints which record the interaction between the artist and the machine. Often the prints are not viewed by their creators as finished works of art but only as visual information about the process. Sheridan exhibits her sequential works in long strips which resemble computer printouts. This preserves the sequence of her thought process.[1]

Other Generation One artists share curiosity about the processes, but choose to develop aesthetically meaningful works of art. Pati Hill produced the prints for the swan on the IBM Copier II because it provided a special pictorial effect. Hill had been introduced to the IBM copier by Charles Eames, the designer known for his chairs, and consultant to IBM. Charles Arnold develops his careful still life prints for their subtle relationship of shape and form. Arnold works with a special white toner that was developed for use in xeroradiography, a medical process which images with x-rays instead of light. He was introduced not only to the toner but to the Haloid/Xerox equipment by a scientist who worked at a Xerox research facility. Other Generation One artists like Arnold have formed productive relationships with the scientists or industry. Tom Norton, a research fellow at MIT works with a process that makes images from a video screen placed on the platen of a color copier. Through further experiments with one former Xerox research scientist, Norton continues to refine and develop his unique system.

The most notable example of the artist who maintained a productive relationship with industry is Sonia Sheridan. First in 1969 and again in 1976, Sheridan was Artist–in–Residence at the 3M research facilities in St. Paul, Minnesota. She formed many lasting friendships with the scientists and engineers. The experience seemed to mutually benefit both the scientists and the artist. Her friendship with Dr. Douglas Dybvig, the inventor of the Color-in-Color copier, saw his transformation from scientist to artistic collaborator. Dybvig made the prints on the Color-in-Color which Sheridan and Keith Smith exhibited as large banners of a male figure in the Museum of Modern Art in 1974. He wrote to Sheridan: "I feel a bit like Frankenstein, first making the machine and now the body."[2]

[1]Interview with Sonia Sheridan, Chicago, Illinois, November 18, 1978.
[2]Interview with Dr. Douglas Dybvig, 3M Company, St. Paul, Minnesota, February 1, 1979.

6. Thomas Barrow, from artist's book
 Trivia 2, 1973.

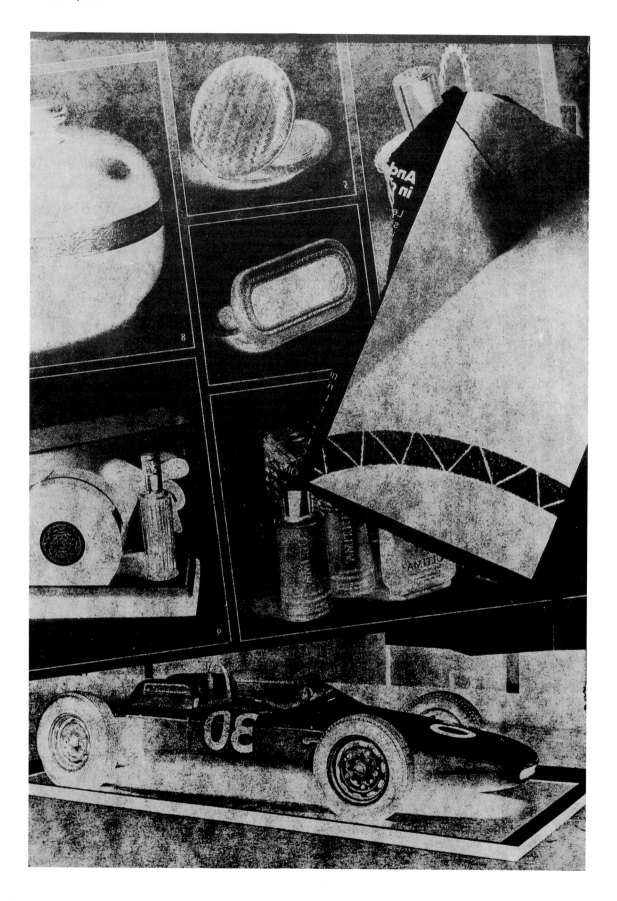

30. Esta Nesbitt, Transcapsa, Untitled, 1971.

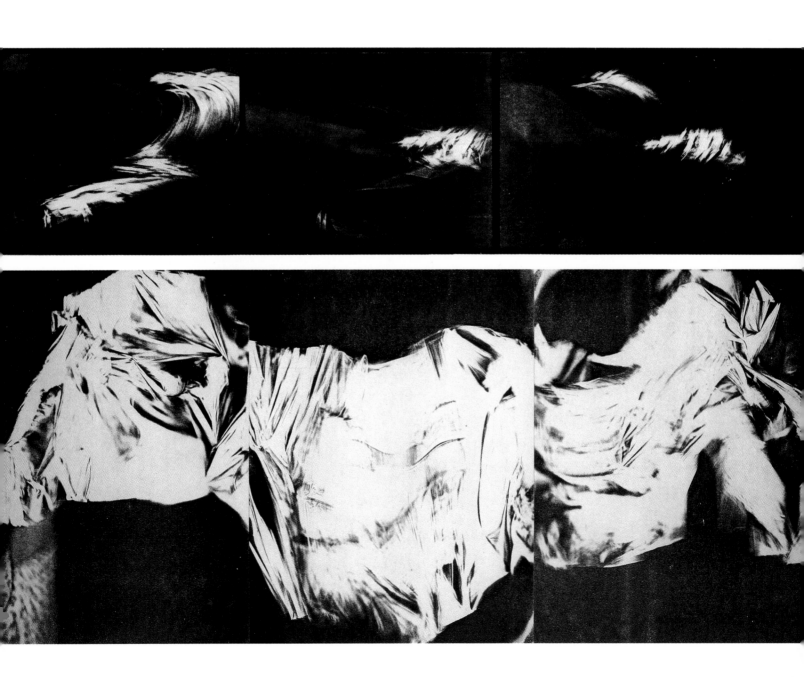

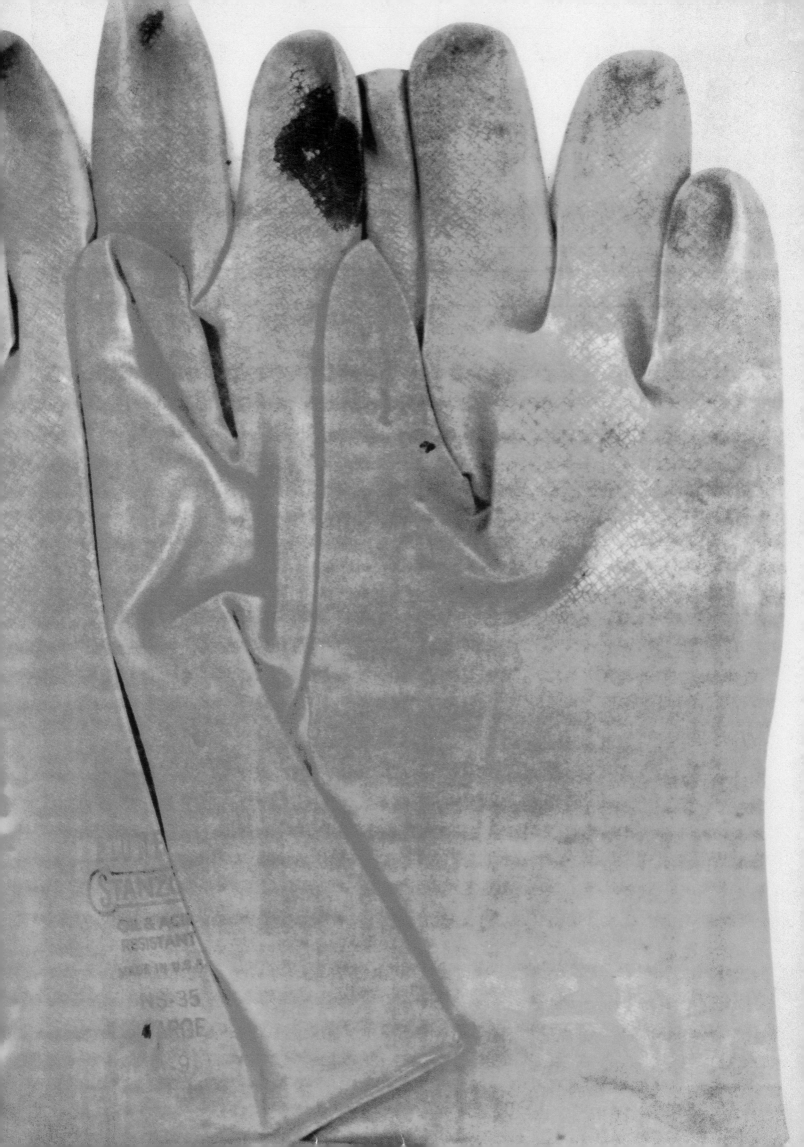

1. Charles Arnold, Jr., Untitled (Fetish
 Thing), 1977.

43. Sonia Landy Sheridan, Robert
 Gundlach, 1977.

57. Sonia Landy Sheridan, Douglas
 Dybvig, 1970.

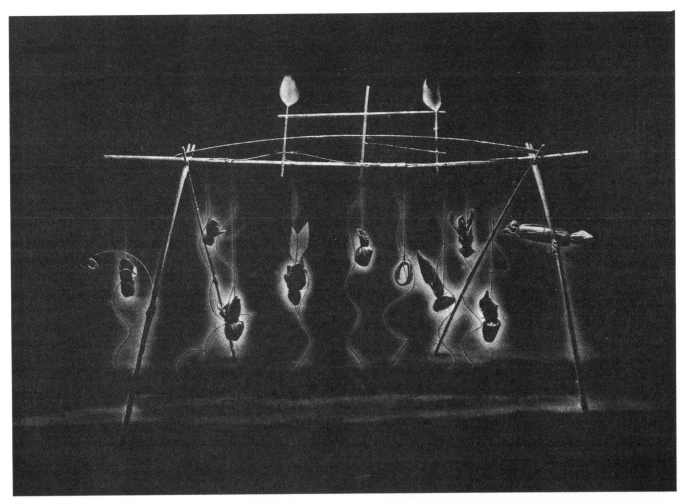

1.

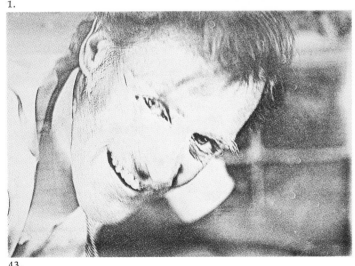

43.

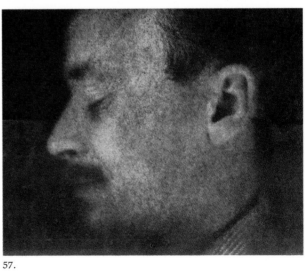

57.

Opposite page

35. Sonia Landy Sheridan, Al Button's
 Dye Gloves, 1970.

34. Sonia Landy Sheridan, Hand With
 Hearts, 1976.

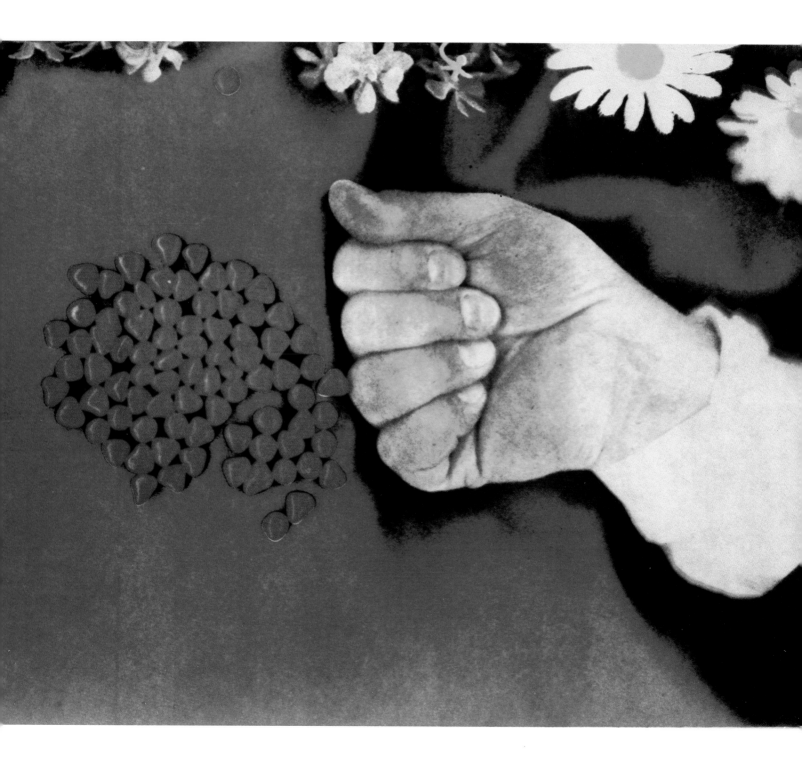

21. Bruno Munari, Original Xerograph, 1970. 28. Esta Nesbitt, Chromacapsa, Portrait I
(C. Peter McColough, now Chairman of
Xerox Corporation), 1971.

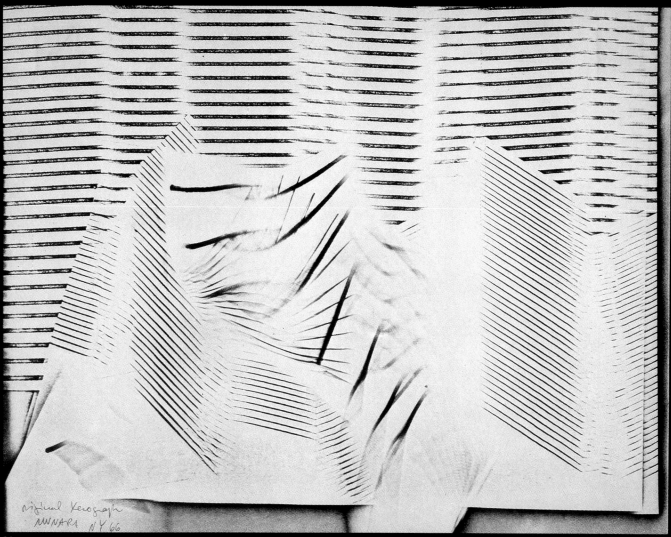

21.

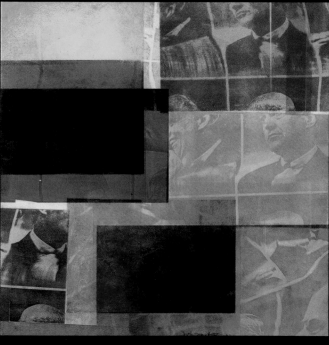

28.

19

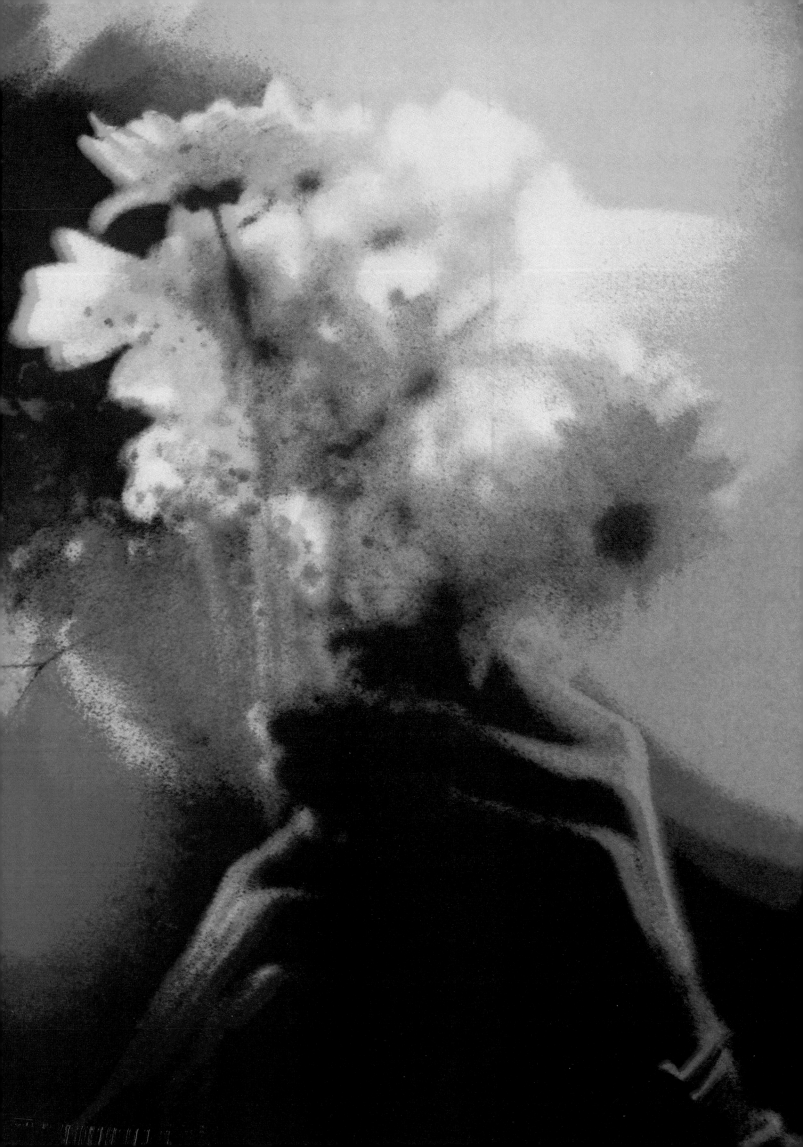

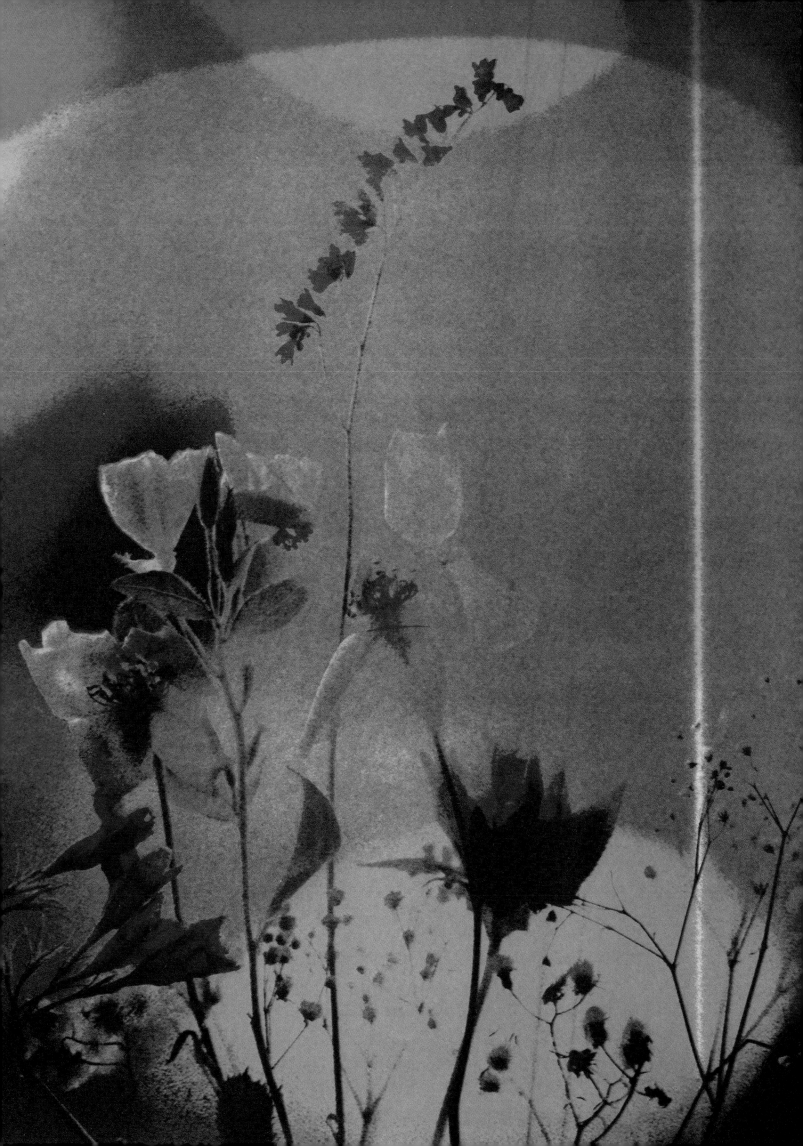

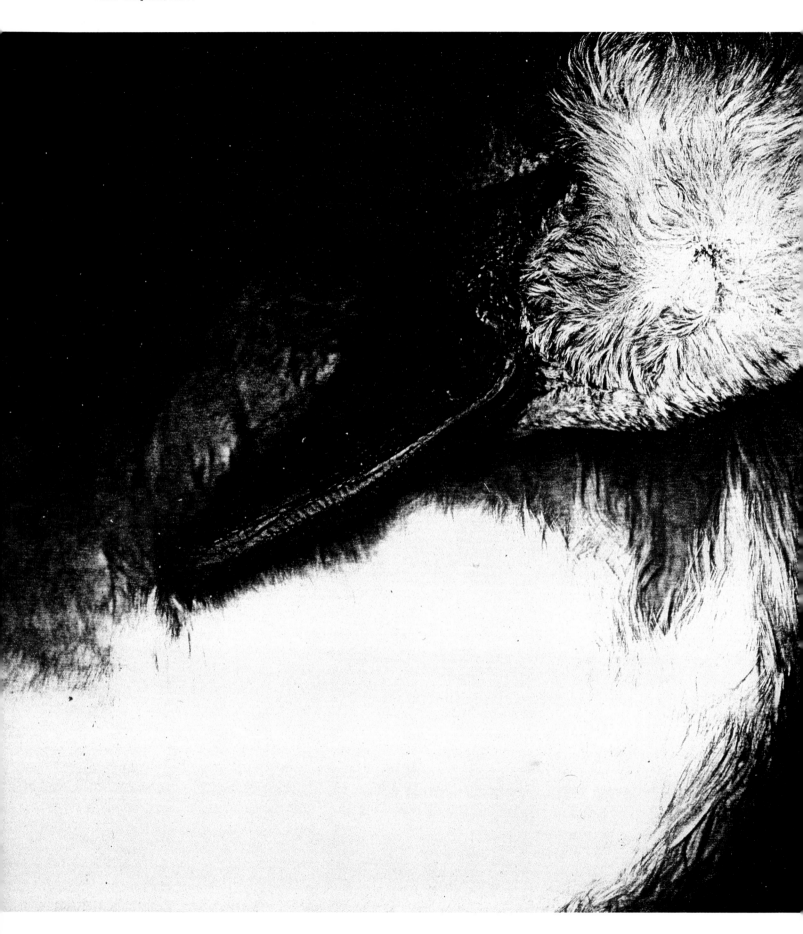

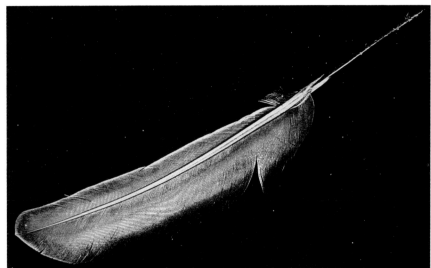

Artists from Generation Two view themselves primarily as art makers who use copying processes as new media. These artists often define their bodies of work in terms of the unique visual qualities peculiar to the copier, and continue to develop or refine aesthetic concerns.

The collaboration between artists of Generation Two and industry is much more informal than between artists of Generation One and industry. This relationship is usually confined to the use of software and machines. Contact with scientists is limited.

Artists with similar approaches to media and subject matter are grouped by categories to aid in comparison of style and attitude.

Although copiers were designed to reproduce two-dimensional subjects, many artists have substituted three-dimensional objects for the customary printed pages. The scientists who engineered the systems in automated copiers directed their efforts toward solving the problems of document copying and were amazed by this slightly unorthodox application of the machines.

Artists construct their compositions directly on the machine's document glass or platen for the sole purpose of creating works of art. No photograph of the object or other two-dimensional print is used as an intermediate stage in the creative process. The machine's camera records the view from beneath the picture platen, which is hidden from the artist's view. The artist must wait for the finished print to emerge from the exit slot of the machine, adding a certain element of suspense to the art-making process as the machine's cycle is completed. Fine points of compositional arrangement, lighting, and other details must be evaluated from the print, not the subject.

Direct imaging prints retain characteristics of the machine's predetermined optical systems. Due to the wide, fixed aperture of the copier's lens, a shallow depth of field effect is obtained. Objects in contact with the glass are rendered in sharp, precisely defined detail that diminishes in areas further away from the glass. The images have a visual verisimilitude, like any other photographic medium.

Connie Fox arranged common hand tools on the platen of the Xerox 6500 for a series of color copier still life prints. Her prints address the specific qualities inherent in the objects she uses; careful attention is paid to shape, texture and detail. In Whiskbroom, 1978, red ribbon tied to the broom is rendered in ultra-realistic detail. The shapes in the patterned fabric, used as background, are defined sharply in the areas that contact the platen, but the same pattern in the fabric fades into vaguely defined shapes in the raised shadow areas. Textures of the wooden handle and metal blades of Tiny Pitchfork, 1978, are distinctly rendered in dull brown tones that contrast with the fabric behind this tool. The veil-like planes of the fabric are saturated blue and yellow hues favored by the synthetic pigments of the color toners.

After working in one manufacturing facility, Douglas Holleley produced a series of direct image prints in response to the "Tech-Talk" vocabulary of the employees. The Ray Gun Catalogue, 1976, is a compendium of fictitious constructions made from laboratory apparatus, electronic components, miscellaneous wires, and light bulbs. Holleley included his own hand in the pictures, in a shooting gesture, to further reinforce the notion of the gun. Holleley's whimsical assemblages are fully deserving of recognition from the maddest of mad scientists. His fiendishly playful texts describe the fantastic functions of each "weapon." As the machine made each scan for color separation, he lifted the lid to create color. By lifting during the magenta scan, a magenta background resulted. Purple background color was created by lifting the lid during both the blue and magenta passes. The machine began to malfunction, creating streaks across the pictures, but Holleley refused to allow the technician to repair the equipment until he finished the catalogue. This "malf"[1] created a very limited edition of prints that could not be repeated on demand.

Due to the fragile, perishable nature of Dina Dar's subject matter her direct image prints are also original and unrepeatable. She composes fresh wildflowers, toys, and ribbons directly on the platen of the copier, as in Slow Boat to China 1978. The heat of the machine's light and fuser create changes in the flowers, limiting the length of working time. Dar is further limited by the seasonable availability of her subject matter; prints with acacia flowers, for example, can only be created when the shrub is in bloom. Dar's prints show distortions that occur in the shape of the pliable, soft objects when placed in contact with the inflexible picture plane, another copier cachet.

[1]The term "malf" is slang from the technical vocabulary.

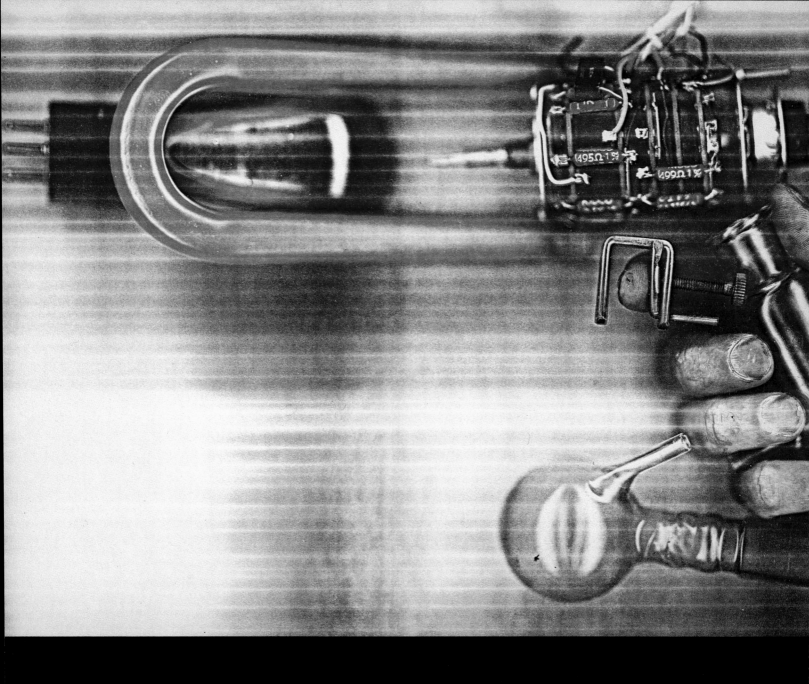

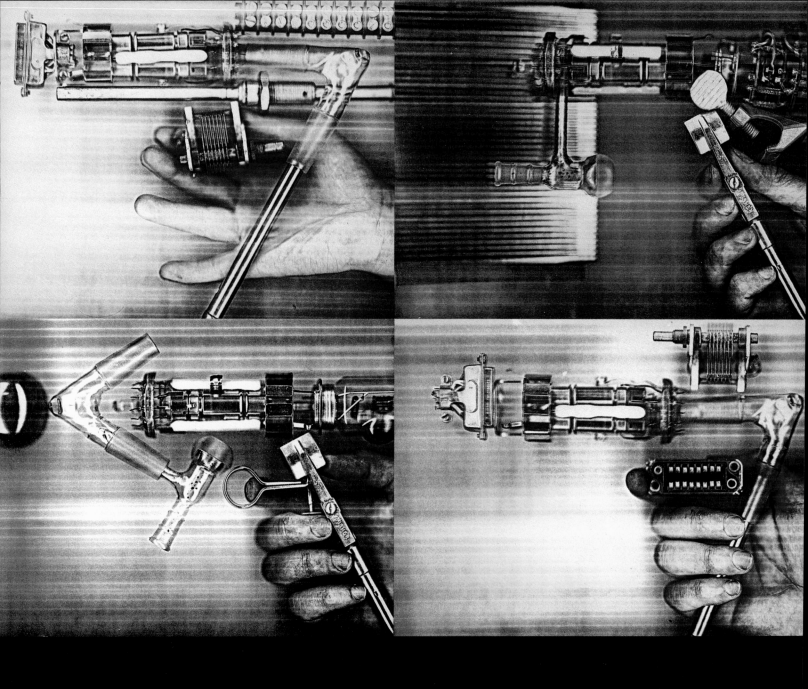

74, 75, 76, 78, 79. Connie Fox, Tools, 1978.

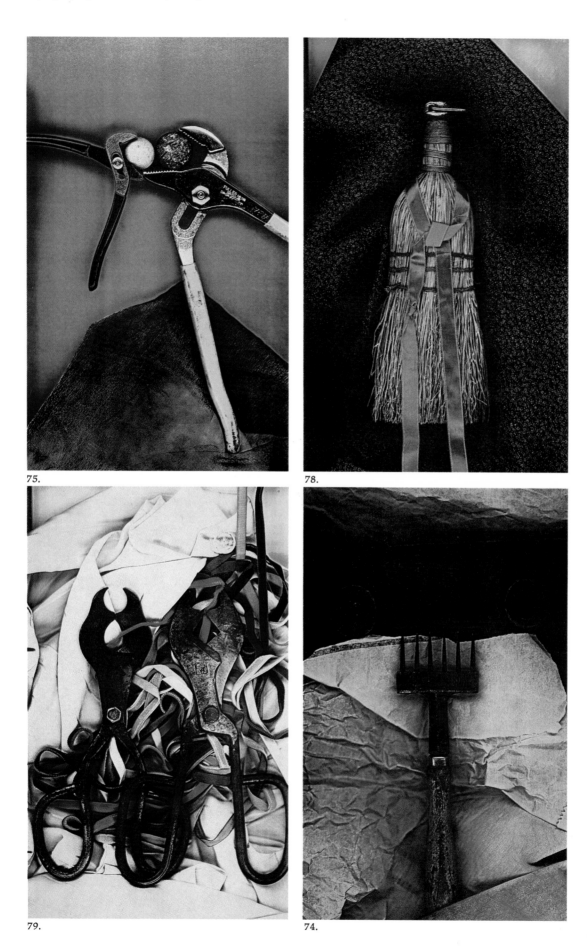

75.

78.

79.

74.

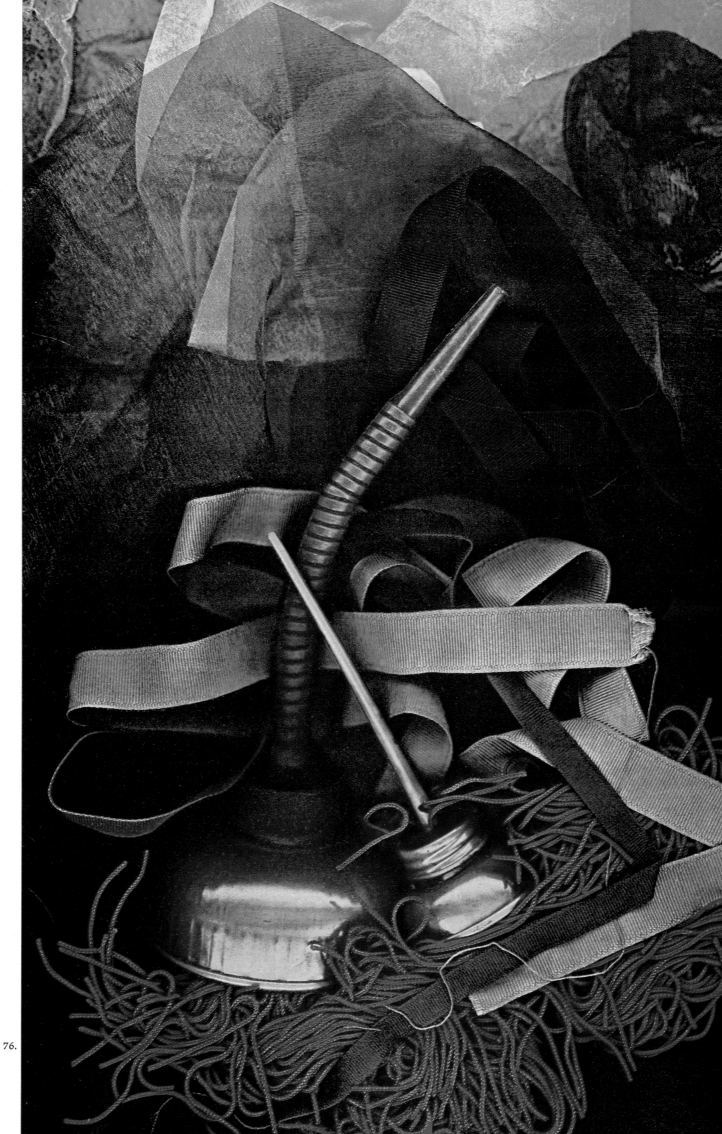

76.

68. Judith Christensen, Evolution
Series #5, 1978.

71. Dina Dar, Slow Boat to China (details), 1978.

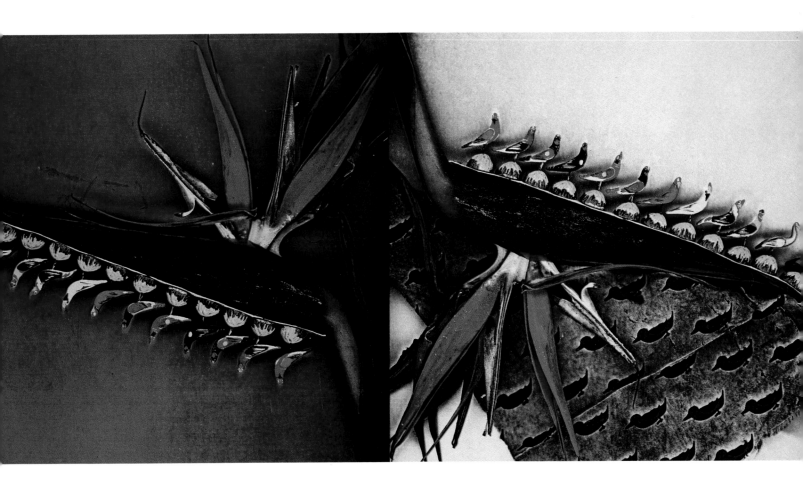

The irresistible urge to record one's own likeness has given rise to a new, copier style of portraiture. Probably the first practitioners of copier portraiture were secretaries and other office workers, who curiously poked their heads under the flap of an automated copier and pushed the button. Artists have explored this new portrait genre, placing their own faces as well as those of friends and even models on the document glass or platen of the machine. (This practice is not recommended by the manufacturers of the machines, however.) The images they create are often unfamiliar and unsettling, but are one of the most unique hallmarks of copier art.

In these images, the picture plane, which has fascinated traditional artists and art historians for generations, has at last physically asserted itself, flattening the noses and transforming the familiar anatomical shapes or contours of the "sitter." These pictures are created from the vantage point of the machine's camera, which is beneath the subject. Gravity also contributes to the unusual, otherworldly appearance of the subject. "Sitting" for a copier portrait is no easy task. It is definitely a participatory event, requiring the sitter to make direct physical contact with the glass, and is not the customary way of making portraits in any other medium.

When Barbara Smith had a Xerox copier in her home she experimented with portraiture. Artist Alan Kaprow described her work: "The harsh grainy details . . . and folds of skin cast the individual one knew into a creature of monstrous intimacy."[1]

Sonia Sheridan, whose work is discussed in the First Generation section of this catalogue, was restricted by the materials she could use in her residency at 3M. Her face, hands and details of her clothing became her subjects. She found that the Color-in-Color and other copying machines could create not only self portraits but portraits of others. In her Color-in-Color print portrait of Dr. Douglas Dybvig, 1970, she presents the image of the inventor of the machine. The soft texture and granular deposits of dye on the print's surface are characteristic of work produced on one of the earliest color copy machines. Sheridan has made portraits of many of the pioneers in the copying industry. In the portrait of Robert Gundlach, 1977, she captures Gundlach's animated smile with the Haloid Xerox Standard Copier, a process he helped to perfect.

William Gray Harris, placing his hands on the platen of the Color-in-Color, stared intently into the machine's lens to make his Self-Portrait of 1973. His penetrating gaze is intensified by the saturation of color and the unfamiliar shadows created by the machine's own light; the striped areas of pure magenta, blue, and green were produced when he preexposed the colored-dye sheets by opening the door on the side of the machine. Because the color areas result from random manipulation, Harris's picture is unique and cannot be duplicated.

Joan Lyons has adapted the Haloid Xerox Standard Copier to create a copier-camera portrait. Using the large view camera and xerographic plates, Lyons records her own image. She then transfers the images from the legal-sized plates to drawing paper to create a larger composite image. Using graphite and other materials in conjunction with the xerographic image, she selectively alters the appearance of the portrait. In a self portrait, Untitled Drawing, 1974, Lyons draws a flowing mass of hair with a pencil, which contrasts with the soft textures and ghostly effects of the xerographic image. For Lyons, the xerographic process is an extension of drawing.

[1]Kaprow is quoted in: Keyes, Ralph, "America's Favorite Reproduction System," *New Times*, January 9, 1976, 40.

Opposite page
94. William Gray Harris, Self Portrait, 1973.

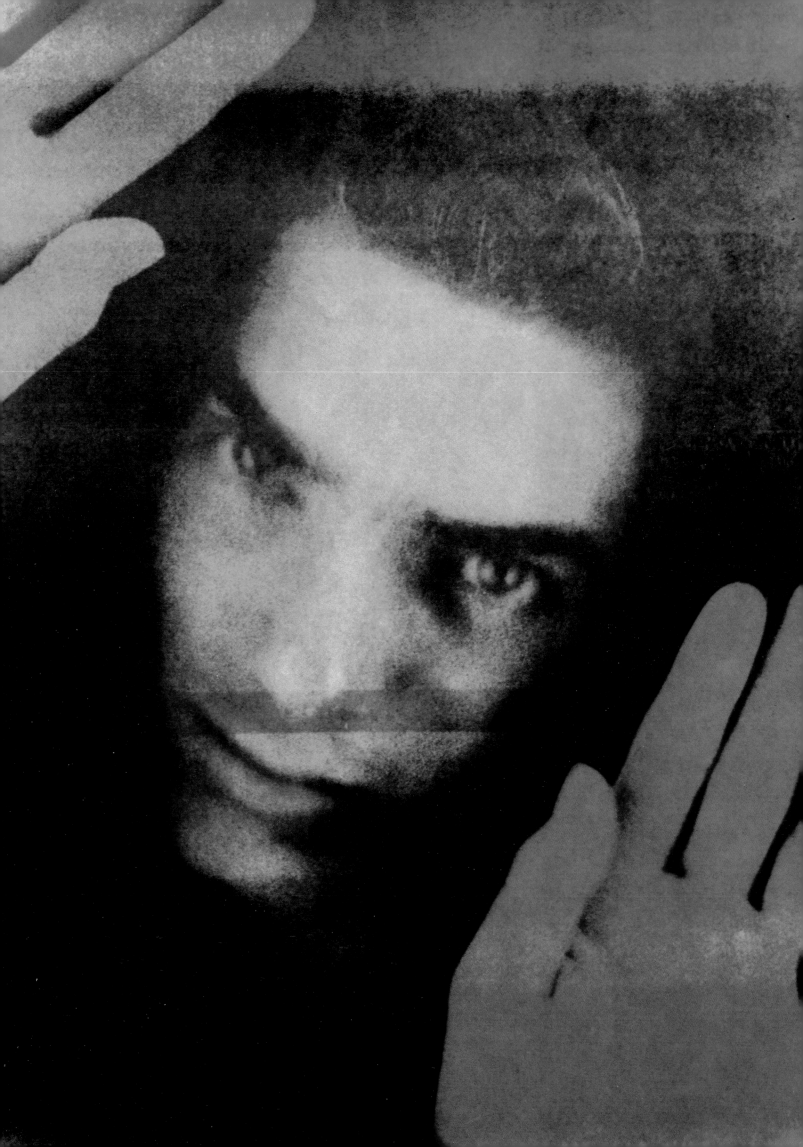

97. Joan Lyons, Untitled (Woman with hair), 1974.

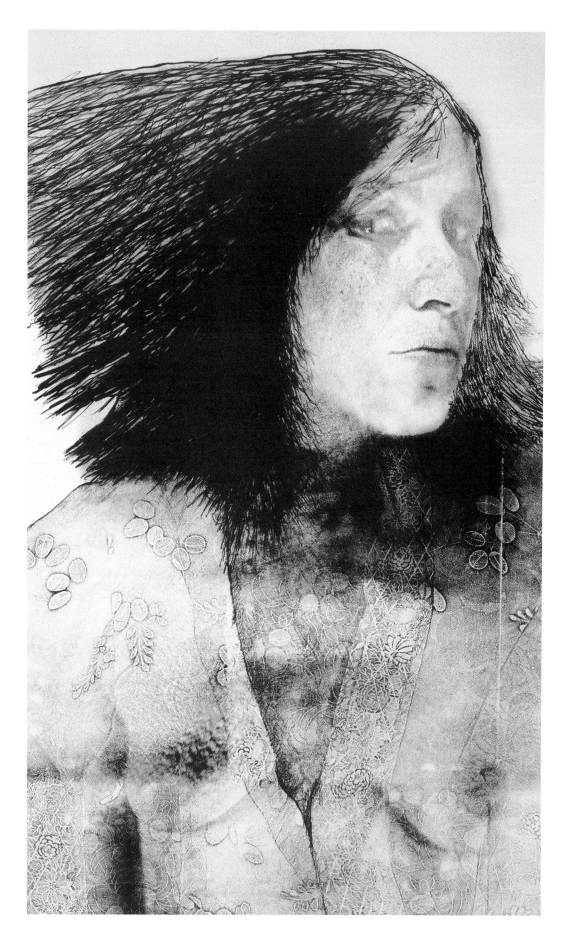

Some artists have embraced the copier for its simplest function—copying. The copier provides an immediate synthesis of objects, images, and other raw materials from diverse sources. This capacity makes the copy machine the perfect photomontage machine. Artists bring a collage technique to the machine and the copier print, not the collage, is the desired result. This composite technique is favored by artists who enjoy constructing their own fantasy worlds; their works frequently parallel the capricious photomontages of the nineteenth century.

Canadian printmaker and photographer Evergon combines his own photographs with magazine illustrations and objects as the raw material for an image vocabulary. He arranges the photographs face down on the platen of the machine and layers the other materials to form personal fairy-tale tableaus. His figures float in a flattened picture space that belies the two-dimensional nature of his subject matter and his process. The cut-out actors often reappear in many visual fantasies.

In an untitled composition of 1976 from the Bondagescape Series, Evergon places the multiple images of a female nude against a landscape populated only by a running horse. He does not explain his enigmatic juxtaposition of these particular images. The cut-out photographs, however, are actually bound, tied up with colored string in a playful comment on the title of the series. Unlike the Forty-second Street concept of bondage, Evergon presents a whimsical fantasy version.

Evergon has utilized special qualities of the machine in his works. The halftone patterns from the magazine illustrations are further enlarged by the machine's own halftone screen. This intensified dot pattern allows him to play with the differences between the textured backgrounds and his photographic subjects. The machine "reads" the textures of the string around the figure and the plastic film placed over one section of the picture differently than the flat surfaces of the other pictorial components. The shiny surfaces of the plastic reflects light back into the lens of the machine and the facets of the "baggie" are sharply defined. These textures provide Evergon with a symphony of visual textures and effects.

Carl Chew created a whimsical new version of George Eastman on safari in Africa 1979. By replacing the gun in Eastman's hand with a "Rochester Three Cent" postage stamp of his own creation, Chew has altered the facts of the photograph.

The multitude of artists in the correspondence and mail art movements have eagerly adopted the copier as a multi-purpose tool. These artists form an international network that encompasses diverse aesthetic attitudes. They proclaim "The mail box is a museum"; copiers have facilitated communications with other participants of the movement.
E. F. Higgins III often creates prints in editions of one hundred or more to accommodate the active participants on his list of correspondents. Higgins, like many other mail artists, creates sheets of fictitious postal stamps. Like the official-issue stamps, these sheets bear the likeness of famous personages; in this case, however, the faces that stare out of the perforated sheets belong to the other artists in the movement. In Pyramid Issue: Doo Da Post, 1978, the main personages are Ray Johnson, founder of the New York Correspondence School, Tod Jorgensen, who operates a color copier, and Higgins himself. These postage stamps provide a self-perpetuating iconography that documents not only the movement but records the images of the participants as well. In Anna Banana Commemorative, 1979, Higgins has reproduced his portrait of Anna Banana, performance artist and publisher, on the sheet of stamps. He has used gummed paper and perforated the paper to heighten the illusion.

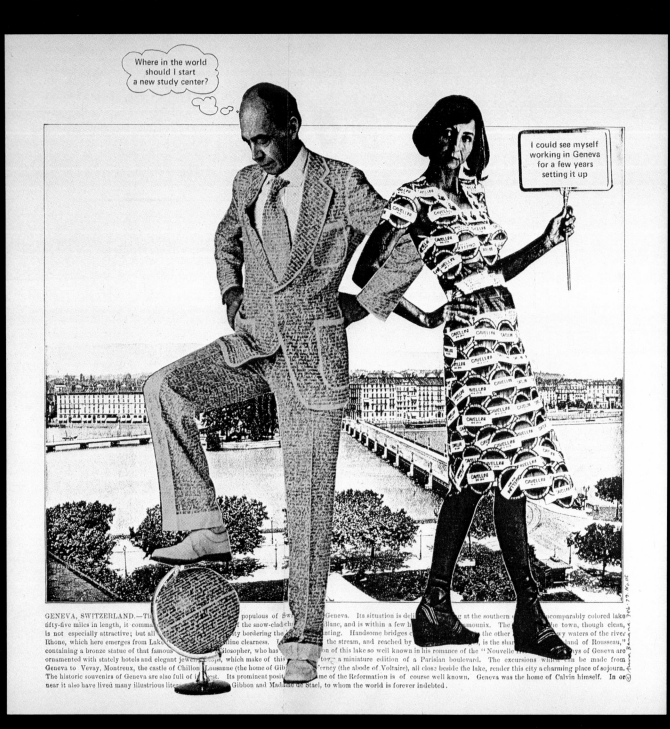

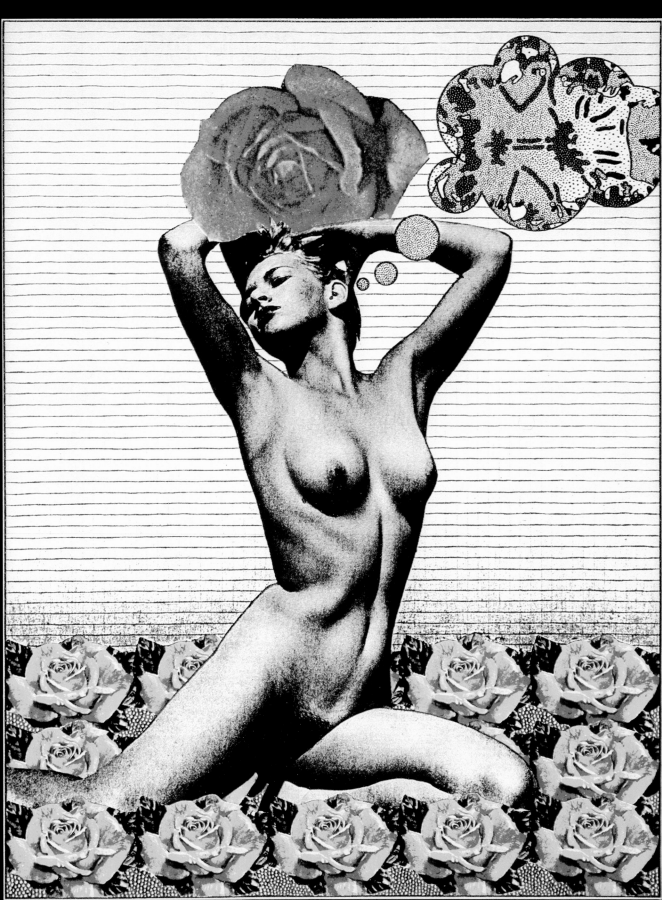

163. H. Arthur Taussig, Picnic for a Camel
Mile, 1972.

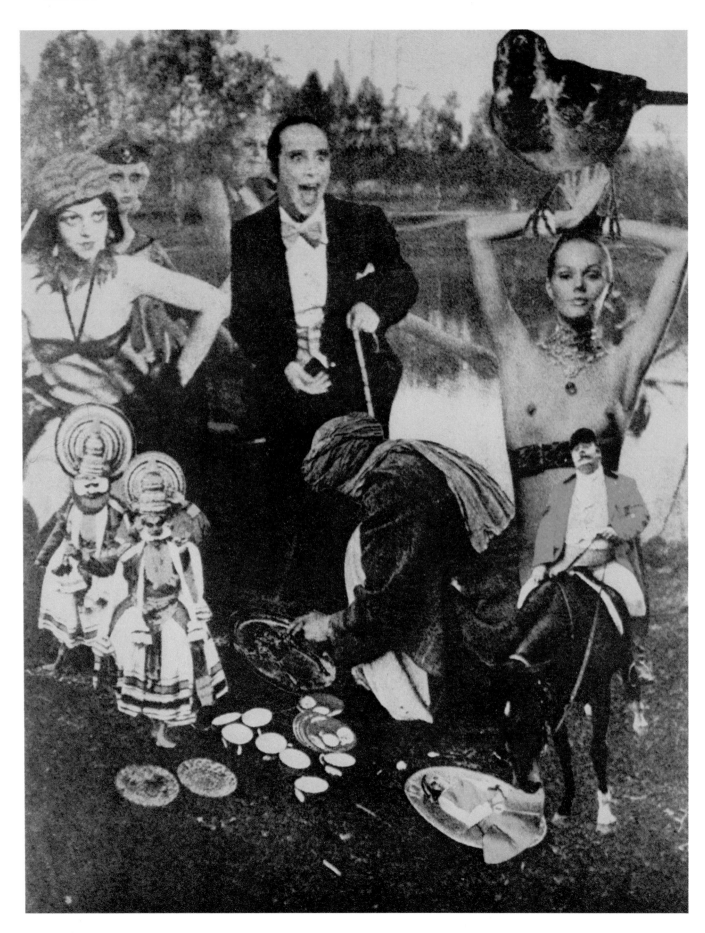

111. Carl T. Chew, George Eastman Hunting Elephant with Stamp, 1979.

165. Helen Wallis, Gertrude Stein Series #1, 1976.

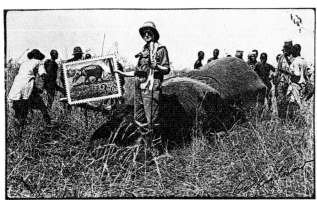

111.

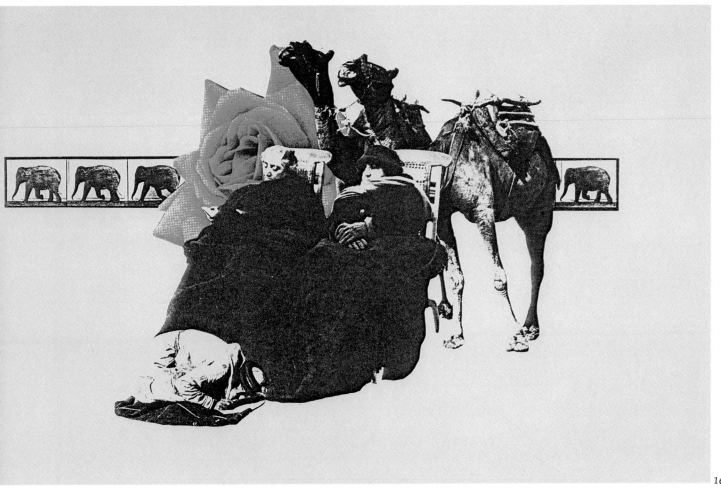

165.

153. Willyum Rowe, Insanity in America:
 Sketch Book Volume I, Xerox Edition
 Two, Page Number 100, 1975.

152. Willyum Rowe, Insanity in America:
Sketch Book Volume I, Xerox Edition
Two, Page Number 94, 1975.

150. Willyum Rowe, Insanity in America:
Sketch Book Volume I, Xerox Edition
Two, Page Number 101, 1975.

152.

150.

Following pages

110. Carl T. Chew, C. T. Chew Eats
Stamp, 1978.

139. E. F. Higgins III, Famous Art Series:
Doo-Da Post, 1978.

41

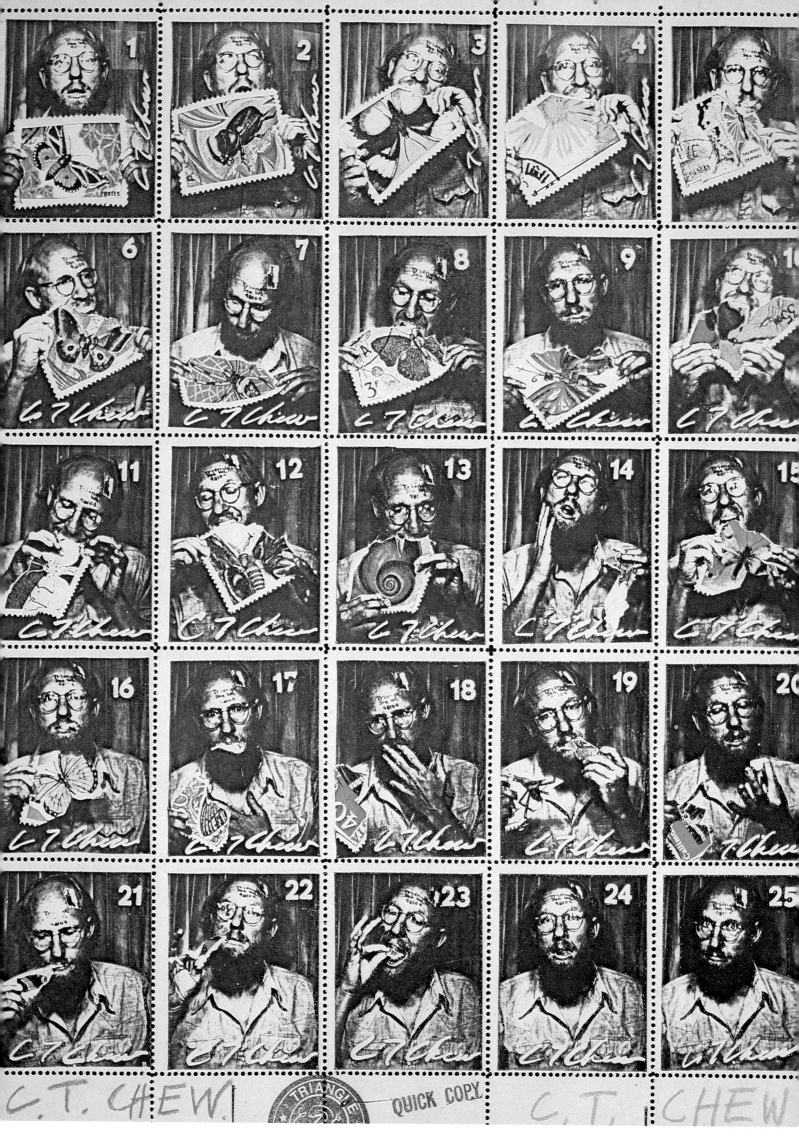

TRIANGLE QUICK COPY

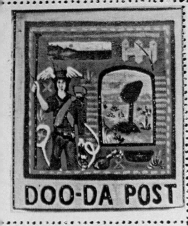

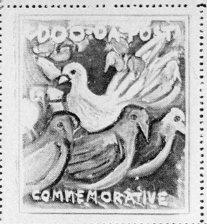

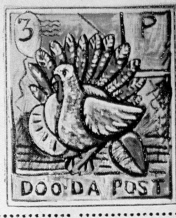

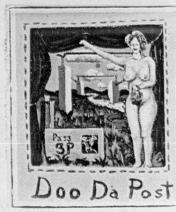

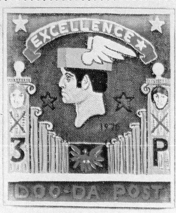

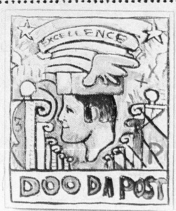

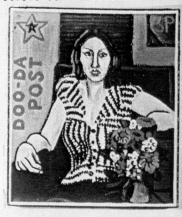

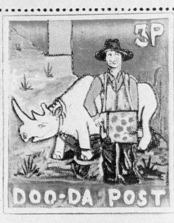

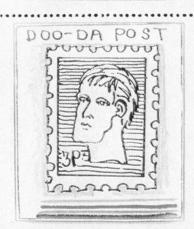

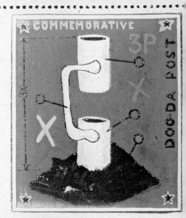

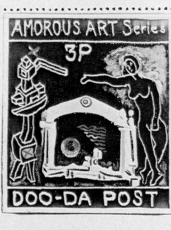

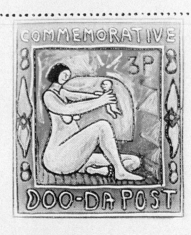

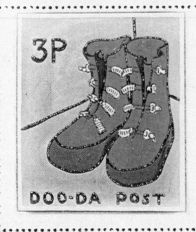

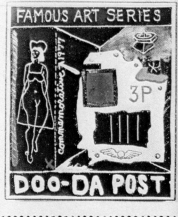

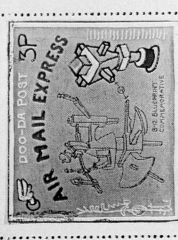

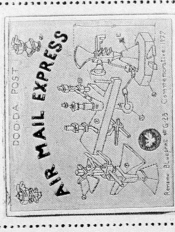

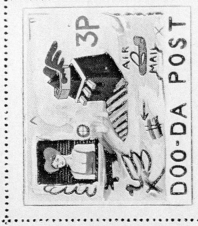

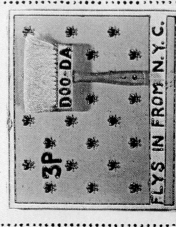

140. E. F. Higgins III, Pyramid Issue: Doo-Da
 Postage Works, 1978.

Opposite page
116. Evergon, Untitled, 1978.

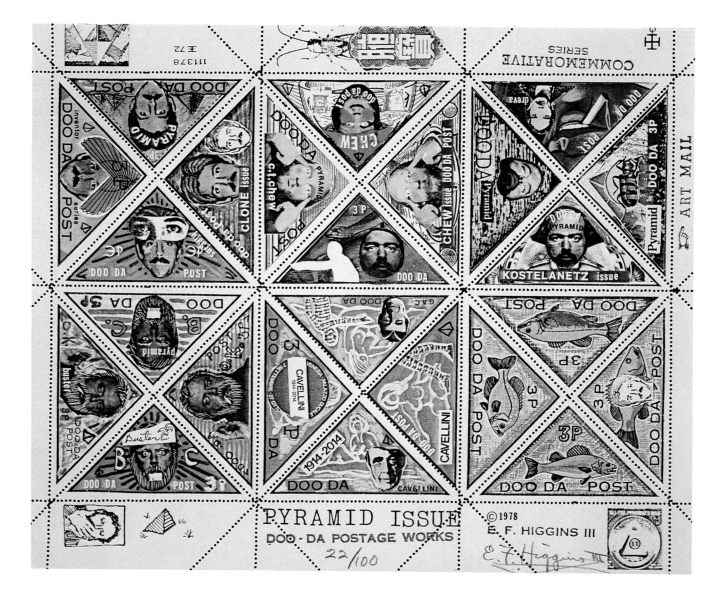

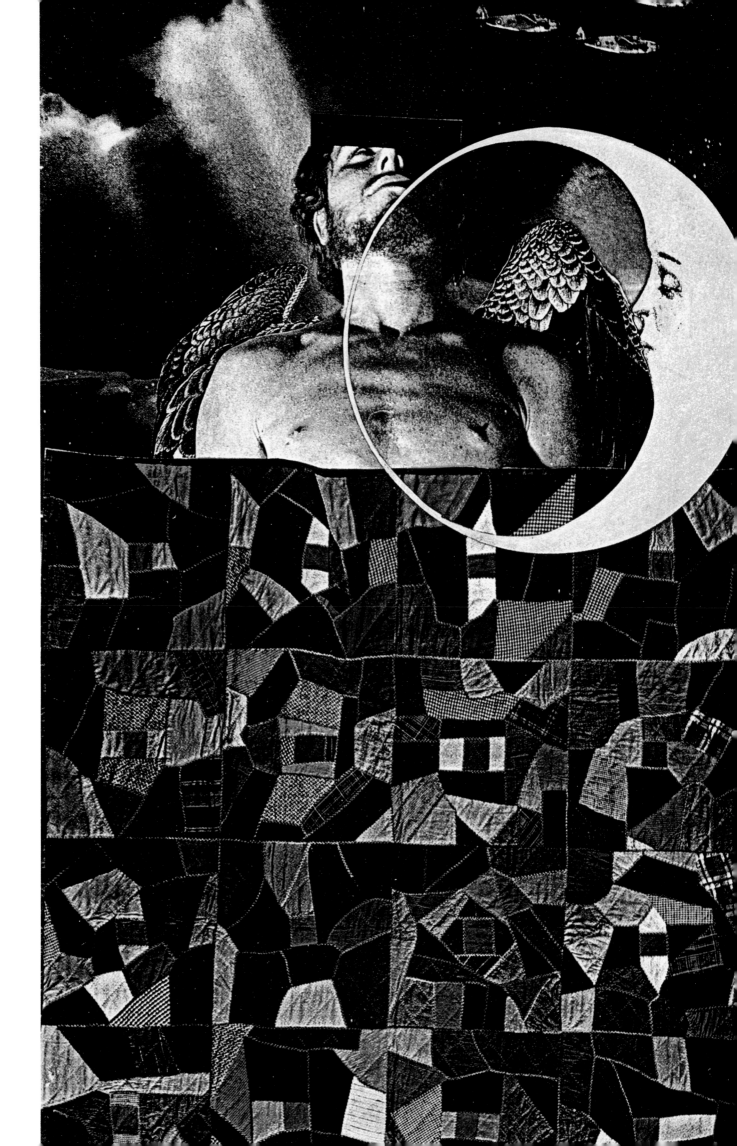

148. Jill Lynne, SpaceScape: Flying—Over
 Earthviews From The Moon, 1978.

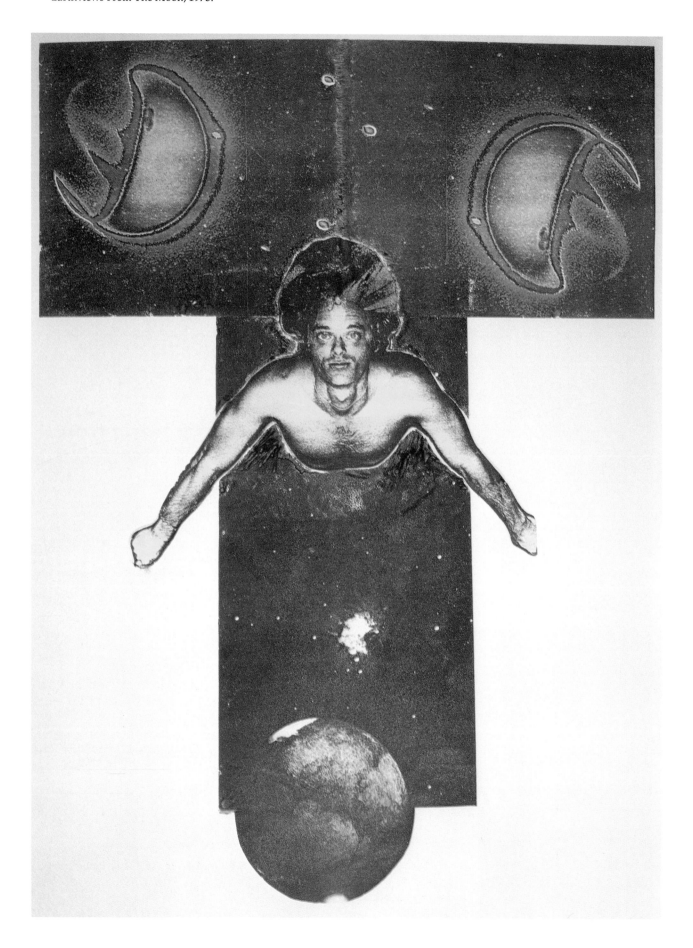

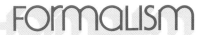

A formalist will work with almost any media. The concerns of a formalist are focused on the elements of picture-making—pictorial structure, shape relationships, and color. Images and shapes are arranged not to create fantasy or narrative but for the purpose of making art. Copiers are adopted by formalists for specific qualities of color or texture that are unique to these processes. Often, machine imagery is combined with drawings or other kinds of work that retains the definite mark of the human hand.

In Margaret McGarrity's Untitled 1977 Haloid Xerox prints nonnarrative relationships of shapes are used. Seashells and her own hand are used in one composition made by photogramming, a noncamera photographic technique in which objects are placed in contact with the photosensitive surface. The xerographic plate records the shapes of her finger and the shell as one shape. In the print, the finger seems to curl out into a delicate curve that ends in the shape of the shell. The forms in McGarrity's prints are the same size as the subjects, a result of the direct contact between subject and surface. In her compositions, it is the shapes and textures that are important rather than the detailed, photographically rendered appearance of a direct-image print.

Charlotte Brown had explored painting and ceramics before using copiers in her work. Her interests center around the tactile values of her materials. Brown begins with color copier images generated from her own drawings, paintings, fossils, and other found objects.[1] She owns a 3M Color-in-Color Computer (a variation of the 3M Color-in-Color copier) and has programmed the machines for well over one thousand color combinations. With the expanded capabilities, she can recreate any color combination. Brown's color copy materials are transferred to bisque-fired ceramic tiles. The synthetic color schemes, which favor magenta, contrast with the earth tones and irregular textures of the clay. Brown also began to make transfers of copy images to her own handmade paper. One obvious motivation was to eliminate the breakage of ceramic pieces, but the paper offered Brown yet another texture on which to apply the color. In Fragments, 1979, she has transferred fossil imagery to her paper. The three panels in this piece are variations on the theme of subtle color relationships to surface. Her use of copier color is at the opposite end of the spectrum from the brilliant, highly saturated color scheme most commonly associated with copier color use.

[1]Interview with Charlotte Brown, Syracuse, New York, February 17, 1979.

184. Joan Lyons, Untitled: Xerox Drawing,
 1978.

200. Rob Noah Wynne, Untitled, 1975.

Following pages
168. Peter Astrom, Bent Flowers, 1979.

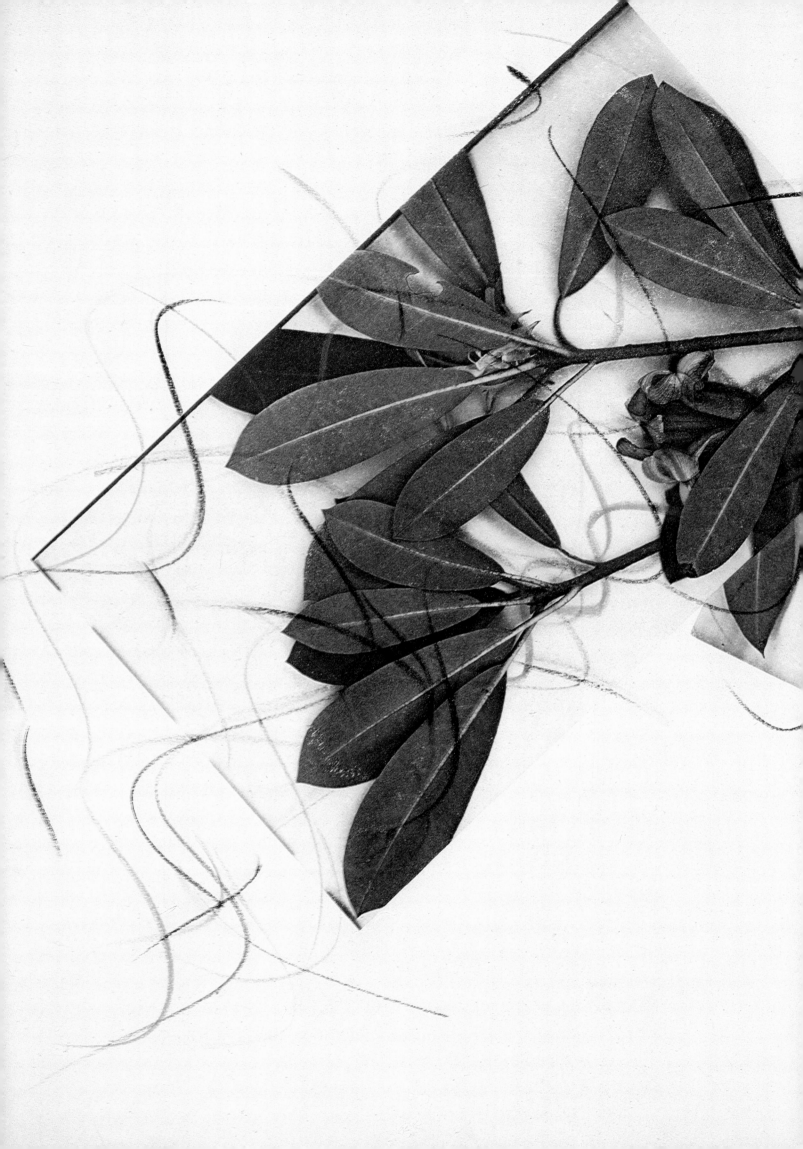

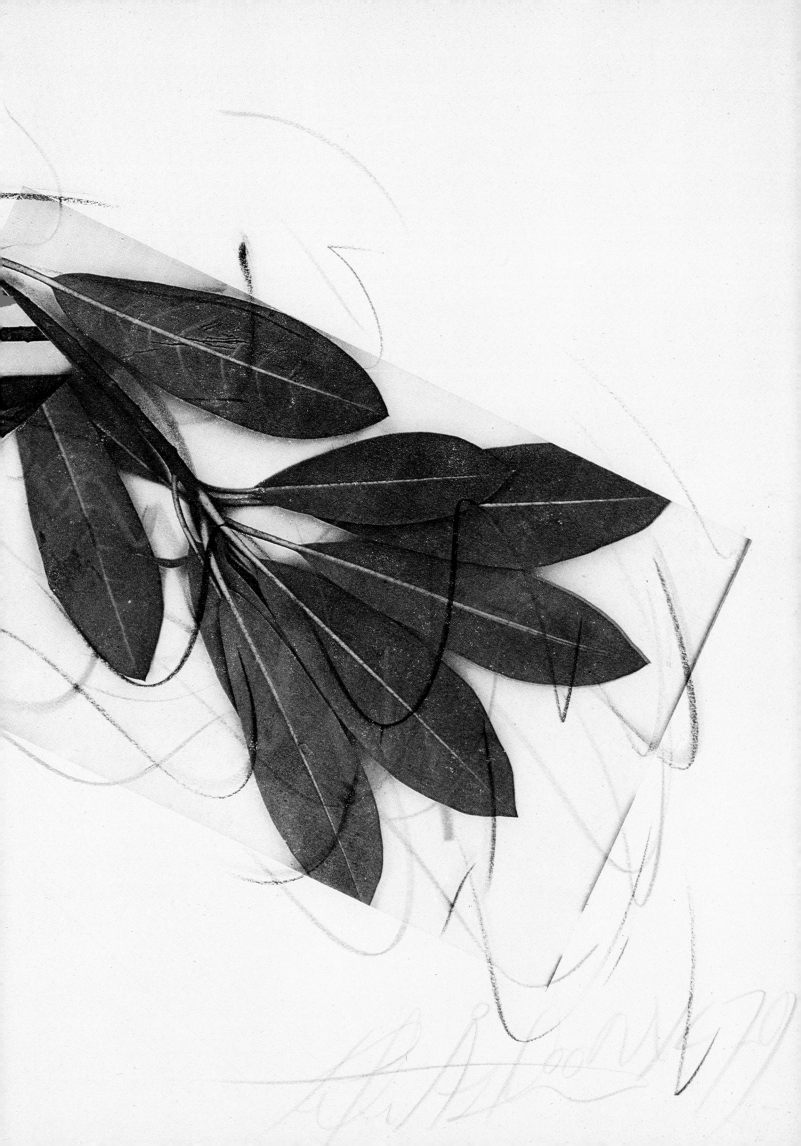

Artists have taken the copier print off the wall and created three-dimensional works of art. No longer confined to letter- and legal-size paper, or for that matter to paper at all, copier prints have become T-shirts, jewelry, quilts, books, and sculpture. Special papers or matrices developed for each color copy system make it possible for the artist, by applying heat, to transfer images produced in the machine to other surfaces. Other special materials, as transparencies for overhead projections, have also been used to create works in other dimensions.

The T-shirt craze supplied one of the first commercial uses for the heat-transfer materials. In the early stages of development of 3M color, Dr. Douglas Dybvig, inventor of the 3M Color-in-Color Copier, and Project Director Donald Conlin ran a T-shirt booth at the Minnesota State Fair with one of the early color machines.[1] They were experimenting with other uses for the machine than making paper copies. In response to the designer clothing fad, Canadian artist Barbara Astman created a series of her own "designer" T-shirts. Using Xerox 6500 Color Copier prints from her own hand-colored photographs, she transferred the subject's image to the cotton shirt. An oversized signature, the "designer's trademark," has been added to the midsection of the shirt to complete the "look." Three Polaroid photographs which document the owner modeling the creation appear beneath the shirt.

Diedre Engle used transfer paper and the Xerox 6500 with her own photographs to create Quilt, 1977–1978. As the subject for the quilt, Engle selected four models from a housing tract in Henrietta, a suburb of Rochester, New York, and photographed the backyards. Each rectangle in the quilt shows a variation on one of the four themes; the color of the aluminum siding varies, as do the other suburban accessories of fences and swimming pools. The image of a coiled garden hose is repeated to form the frame and a generic garage is used as a border. In this bed-sized cotton quilt is a twentieth-century, "Hi-Tech" update of an early twentieth century cyanotype, or blue print, quilt that also incorporates architectural images as subject matter. (Collection of International Museum of Photography at George Eastman House)

Betty Hahn used xerography to re-create a nineteenth-century photographic artifact. In Soft Daguerreotype, 1973, she used the Haloid Xerox manual copier and an electrostatic charge, rather than the matrix, to transfer the image to fabric. Hahn chose a shiny fabric to approximate the reflective mirror surface of the Daguerreotype and made a red velvet case to contain the jumbo-size image.

Artists are also using the copier for its originally intended purpose—reproduction. All manner of artist-created books, literary journals, and magazines are being produced on black-and-white as well as color copiers. In Marshall McLuhan's words, ". . . Caxton and Gutenberg enabled all men to become readers, Xerox has enabled all men to become publishers."[2] The contemporary concept of artist's books became popular with such small-press offset lithography publications as Edward Ruscha's Twenty Six Gasoline Stations, 1962. Many artists, however, have found that the copier offers speed as well as convenience and began publishing editions on various copiers. John Eric Broaddus used the Kodak Ektaprint Copier–Duplicator to produce The Sorcerer, 1979, a black-and-white book. The reader is presented with a series of views in which the sorcerer is visible only through the handcut openings in each page and is finally revealed on the last page.

In Telling Time, 1979, Judy Levy used Haloid Xerox images as the masters for this offset lithography book. She moved the unfused toner to create textures and to erase or alter the images. The entire book assumes a dreamlike quality as images of houses, family members, and toys appear and disappear. The text, written on cards, is placed in library pockets and can be arranged by the reader.

Artists like Anna Banana and Bill Gaglione publish magazines as forums for not only their own works but also for the works of colleagues. Titles like Dadazine, Fe-Mail Art, and others are available from Dadaland and Banana Productions. Copier imagery is reproduced in other media as well as used for small editions.

[1]Interview with Dr. Douglas Dybvig and Don Conlin, 3M Company, St. Paul, Minnesota, February 1, 1979.
[2]McLuhan quoted in: Morrison, Donald, "What Hath Xerox Wrought?", Time, March 1, 1979, 69.

220. Diedre Engle, Quilt, 1977–78.

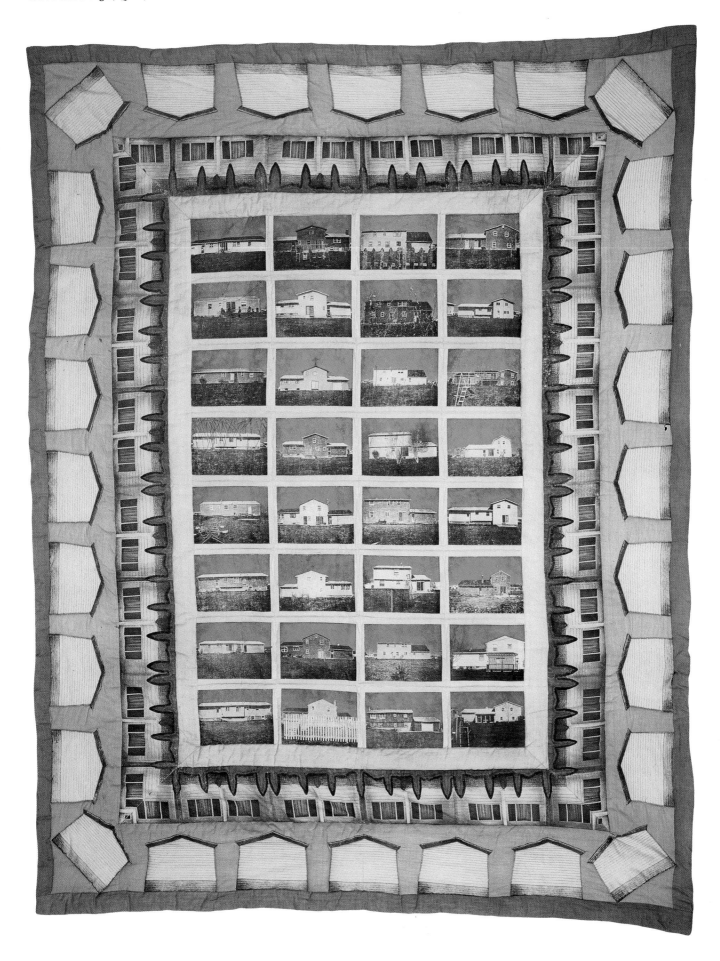

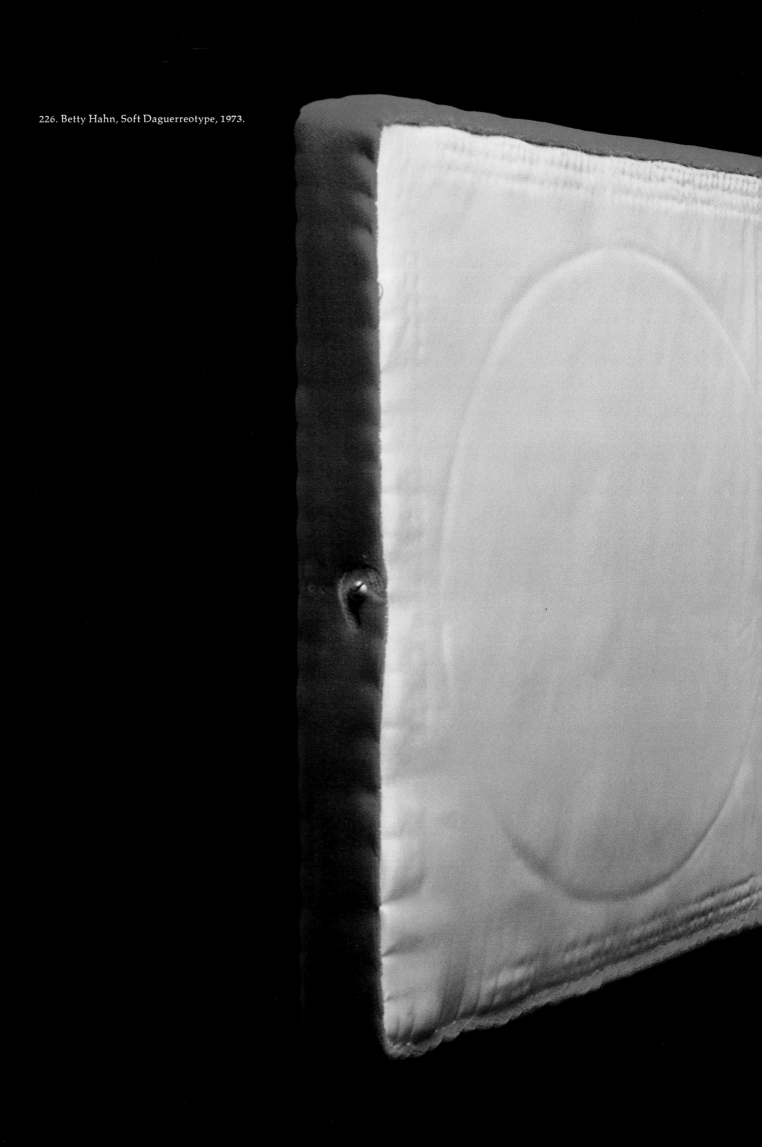

226. Betty Hahn, Soft Daguerreotype, 1973.

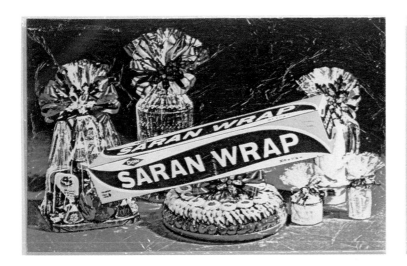

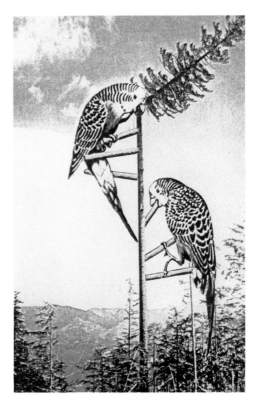

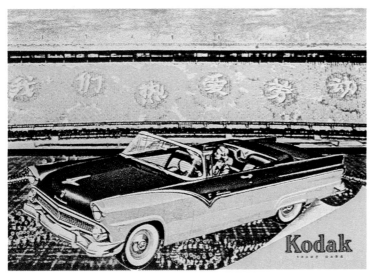

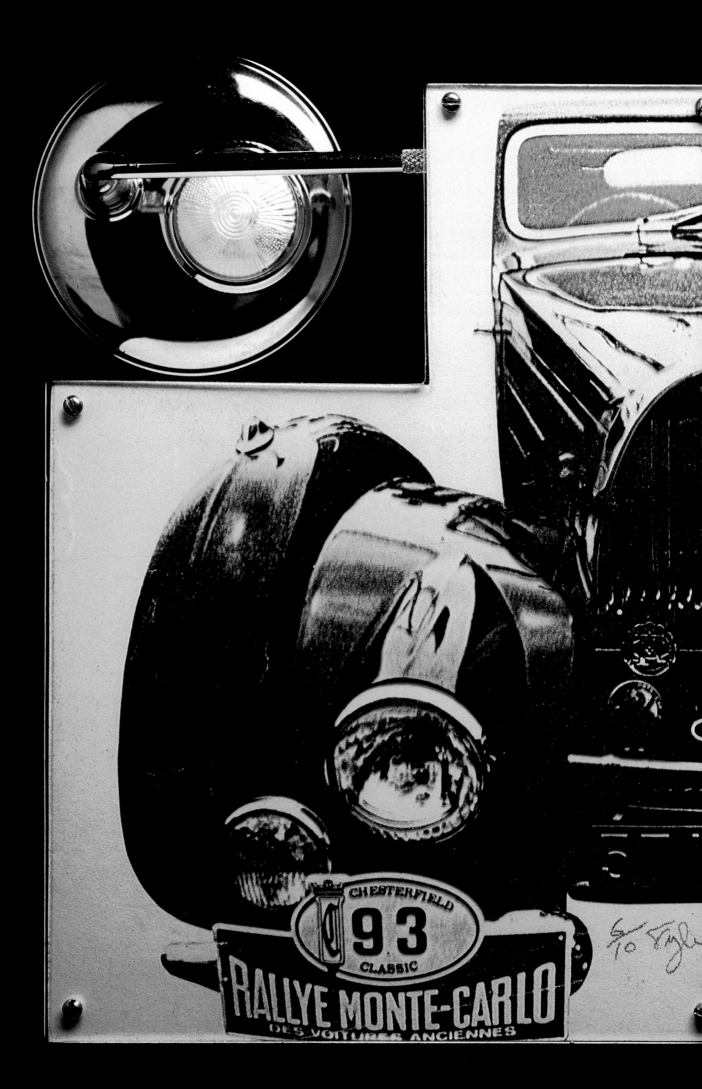

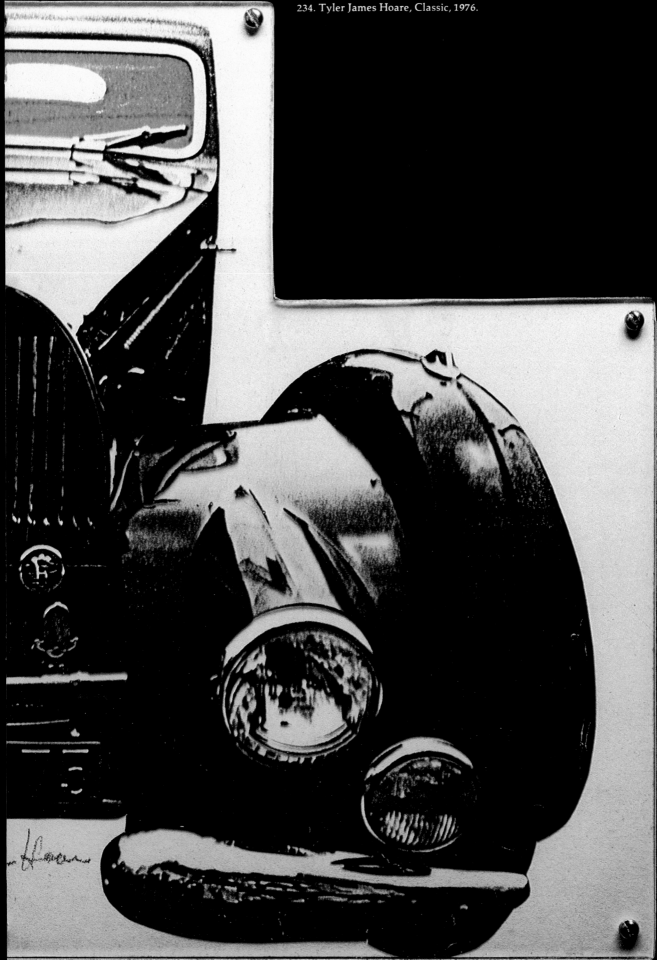

Accame, Giovanni. *Danese Productions and Editions*. Paris: Musée des Arts Decoratifs, Palais du Louvre, January 14–March 9, 1970.

"A Special Survey of Office Copy Equipment." *The International Blue Printer*, February 1944, 22–27.

Adams, Nancy. "And You Thought the Copy Machine Was Just for Memos." *Chicago Tribune*, January 28, 1979.

Apollonio, Umbro, ed. *Futurist Manifestos*. New York: The Viking Press, 1973.

Arnold, Charles. *"An Encounter with Xerography."* Unpublished manuscript.

"Art from Technology." *Industry Week*, October 12, 1970.

"Artist in the Science Lab." St. Paul, Minnesota: 3M Company, 1976.

"Artist Swaps Brush and Palette for Push Button Machine Art, Calls it Interactive Graphics." *Graphics U.S.A.*, June 1971.

"Art Transition." Cambridge, Massachusetts: M.I.T. Center for Advanced Visual Research, October 1975.

Barthes, Roland. *Image—Music—Text*. New York: Hill and Wang, 1977.

_____. *Mythologies*. New York: Hill and Wang, 1972.

Benjamin, Walter. *Illuminations*. New York: Schocken Books, 1969.

Benthall, Jonathan. *Science and Technology in Art Today*. New York: Praeger, 1972.

Boranski, Lynne. "Sonia Sheridan's Students Produce X for Xerox-Rated Work in her Copy Machine Art Class." *People*, April 18, 1977.

Brookes, John. "Xerox, Xerox, Xerox, Xerox." *The New Yorker*, April 1967, 46+.

Burnham, Jack. *Software Information Technology: Its New Meaning for Art*. New York: The Jewish Museum, 1970.

Clough, Rosa Trillo. *Futurism*. New York: Greenwood Press Publishers, 1969.

Coleman, A. D. "3M." *New York Times*, July 14, 1974.

Daubent, Chris, and Thurston, Jacqueline. *Intersection: Photographic Images, Resources, Processes*. San Jose, California: San Jose State University, August 30–September 30, 1976.

Davis, Douglas. "Art and Technology: The New Combine." *Art in America*, January/February 1968.

_____. *Art and the Future*. New York: Praeger, 1975.

_____. *Artculture*. New York: Harper and Row, 1977.

Dessauer, J. H. "Xerography Today." *Photographic Engineering*, 1955, 250–269.

Dinsdale, Alfred. "Chester F. Carlson, Inventor of Xerography." *P. S. & E.*, 1963.

Douglas, Cheryl. *3M Color*. Carmel, California: Friends of Photography, 1973.

Dreyfus, Charles. "From History of Fluxus." *Flash Art*, October–November 1978, 25–29.

"Emerging Los Angeles Photographers." *Untitled 11*, 1977.

"Equipment Spotlight." *Color Engineering*, May/June 1971.

Eynard, Raymond E. *Color: Theory and Imaging Systems*. Teterboro, New Jersey: Society of Photographic Scientists and Engineers, 1973.

Firpo, Patrick; Alexander, Lester; Katayanagi, Claudia, and Ditlea, Steve. *Copy Art*. New York: Richard Marek Publishers, 1978.

Floyd, Howard A. "Color Copiers, We Should be Careful How We Use Them." *Reviews and Methods*, July 1973.

Friedman, Ken. "On Fluxus." *Flash Art*, October–November 1978, 30–31.

Godown, Linton. *Exploring a New Art Medium: Electrographic Monoprints*. Unpublished manuscript.

Goldberg, Roselee. *Performance*. New York: Harry N. Abrams, 1979.

Goldman, Judith. "The Language of Print: Subject and Object." *Print Review*, 1972, 3–10.

Goldwyn, Craig. "Electrostatics." *YONY*, May 1975.

Gottlieb, Carla. *Beyond Modern Art*. New York: E. P. Dutton, 1976.

Gottlieb, Martin. "Copier Art Art Art Art," *New York Sunday News Magazine*, September 29, 1974.

Grey, Ben E. "Color Copiers—How Did We Ever Get Along Without Them?" *Reviews and Methods*, July 1973.

Higgins, Richard. "The Content of Fluxus." *Flash Art*, October–November 1978, 34–37.

Hoffberg, Judith, and Hugo, Joan. *ARTWORDS AND BOOKWORKS*. Los Angeles: Los Angeles Institute of Contemporary Art, February 28–March 30, 1978.

Howell-Koehler, Nancy J. *Photo Images in Art Design Processes and Materials*. Worcester, Massachusetts: Davis Publishing Company. In preparation.

"How Xerography Works." Xerox Corporation. Undated brochure.

Hulton, Karl Gunnar Pontus. *The Machine, as Seen at the End of the Mechanical Age*. New York: Museum of Modern Art/New York Graphic Society, 1968.

Hunter, Sam, and Jacobus, John. *Modern Art*. New York: Harry N. Abrams, 1976.

"In Time." *Untitled 9*, 1975.

"The Inner Landscape and the Machine." Sonia Landy Sheridan traveling exhibition, Visual Studies Workshop, 1974.

Interim Report. Rochester, New York: Xerox Corporation, September 30, 1978.

Karamon, John J. "30 Second Color Prints from Tomorrow's Coin-op Custom Lab?" *Popular Photography*, October 1973.

Keyes, Ralph. "America's Favorite Reproduction System." *New York Times*, January 9, 1976.

Kirkpatrick, Diane. "Between Mind and Machine." *Afterimage*, February 1978, 14–16.

_____. *Chicago: The City and its Artists 1945–1978*. Ann Arbor, Michigan: The University of Michigan Museum of Art.

Kluver, Billy; Martin, Judy, and Rose, Barbara, eds. *Pavilion By Experiments in Art and Technology*. New York: E. P. Dutton, 1972.

Kozloff, Max. *Photography and Fascination*. Danbury, New Hampshire: Addison House, 1979.

Kramer, Hilton. *New York Times*, December 4, 1971.

Lesmez, A. V. "Artists Explore a Brand New Art Form." *Industrial Art Methods*, September 1972, 16–19+.

_____. "Artists Explore a Brand New Art Form," Part II. *Industrial Art Methods*, October 1972, 16–20.

"A Letter From Munari." *BIT*, March 1967.

Magnam, George. *Graphics Today*. Ventura, California, 1977.

Matsueda, Tomoko. "Xerographics: Originals by Copy Cats." *Honolulu Star-Bulletin*, April 29, 1979.

McWillie, Judith. "Exploring Electrostatic Print Media." *Print Review*, 1977, 75–81.

Morse, Marcia. "Copier Art." *Artweek*, April 28, 1979.

Mueller, Robert E. *The Science of Art*. New York: The John Day Company, 1967.

Munari, Bruno. Unpublished résumé.

_____. "Statement." Milan: Rank-Xerox.

_____. *Xerografia*. Milan: Rank-Xerox, 1970.

Murray, Joan. "Magic Machines." *Art Week*, December 1973.

_____. "People and Machines." *Art Week*, December 1971.

"Photokino." Cologne, Germany, 1974.

Poggioli, Renato. *The Theory of The Avant Garde*. New York: Harper and Row, 1968.

"Printing With Powders." *Fortune*, June 1949, 113–116+.

Raymo, Jim. *Generative Systems*. Notre Dame, Indiana: St. Mary's College, 1976.

Rothschild, Norman. "Would You Believe? 20 Cent Color Prints in 20 Seconds?" *Popular Photography*, March 1976.

Ruspoli, Rodriguez. "Color-in-Color With Art." *Popular Photography*, January 1974.

Schaffert, R. M. *Electrophotography*. London and New York: The Focal Press, 1965.

_____. "Xerography and Xeroprinting." *The Penrose Annual*, 1950.

Schaffert, R. M., and Oughton, C. D. "Xerography: A New Principle of Photography and Graphic Reproduction." *The Journal of the Optical Society of America*, December 1948, 991–998.

Scharf, Aaron. *Art and Photography*. Harmondsworth, England: Penguin Books, 1968.

Sheridan, Sonia Landy. "Generative Systems." *Afterimage*, April 1972.

_____. "Generative Systems a Decade Later: A Personal Report." *Afterimage*, February 1978.

_____. "Generative Systems—Six Years Later." *Afterimage*, March 1975.

Sheridan, Sonia, and Kirkpatrick, Diane. *Energized Artscience*. Chicago: The Museum of Science and Industry—A Generative Systems Publication, 1978.

"Short-run Color Markets and Methods." Rochester, New York: Graphic Arts Research Center, Rochester Institute of Technology, 1973.

Sobieszek, Robert A. "Composite Imagery and the Origins of Photomontage." *Artforum*: Part 1, September 1978, 58–65; Part 2, October 1978, 39–45.

Soper, Susan. "Xerography." *Newsday*, April 27, 1976.

Tait, Jack. *Beyond Photography*. New York: Focal Press/Hastings House/Visual Communications Books, 1977.

Tenton, Terry. "On Art and Technology." *Studio International*, January 1969.

"3M's Marvelous Machines." *Communication Arts*, October 1973.

"What Hath Xerox Wrought?" *Time*, March 1, 1976.

"When the Medium is the Message." *Christian Science Monitor*, February 7, 1977.

Wickstrom, Richard D., and Sheridan, Sonia Landy. "A Generative Retrospective." Iowa City, Iowa: University of Iowa Museum of Art, March 5–April 21, 1976.

Williams, Alice. "Jill Lynne." *Popular Photography*, 1977, 89+.

Wilson, William. *Correspondence—An Exhibition of the Letters of Ray Johnson*. North Carolina Museum of Art, October 31–December 5, 1976.

"Women Photographers." San Francisco, California: San Francisco Museum of Art, 1975.

Wong, Jason. "Photography." *Art International*, October–November, 1976.

"Xerography." *Portfolio Magazine*, Zebra Press, Winter 1950.

"Xerox and Xerography." Audiovisual presentation to the Industrial Research Institute, 1964.

PATRICIA AMBROGI
Patricia Ambrogi studied in Italy and at the State University of New York at Albany, majoring in studio art with emphasis in photography; she then studied photography at the Visual Studies Workshop in Rochester, New York, working with Nathan Lyons, Keith Smith, and Sonia Sheridan. Ambrogi teaches basic and nonsilver photography at the Allofus Art Workshop in Rochester, and lives in Penfield, New York.

CHARLES ARNOLD, JR.
Born in Providence, Rhode Island, in 1922, Charles Arnold, Jr., graduated from the Rhode Island School of Design with a B.F.A. in 1949. He then became assistant to Beaumont Newhall at the George Eastman House in Rochester, New York; he also worked with Minor White and was design consultant to *Aperture* magazine. Arnold later taught photography at the London Poly-Technic School of Photography and was an adviser to *Editora Abril*, São Paulo, Brazil. He is now a professor of photography at Rochester Institute of Technology, Rochester, New York.

BARBARA ASTMAN
Barbara Astman was born in Rochester, New York, in 1950. She received an A.A. in photography in 1970 from Rochester Institute of Technology and an A.O.C.A. in 1973 from the Ontario College of Art, Toronto, Canada, where she teaches experimental multimedia. In 1978, she was appointed consultant to Visual Arts Ontario in charge of the Colour Xerox Artists' Program. Her work is included in the collections of the National Film Board of Canada, the Art Gallery of Ontario, and the Ontario Arts Council.

PETER ASTROM
Peter Astrom, who was born in Stockholm, Sweden, in 1946, studied there at Bergh's Art School and at the School of Visual Arts in New York. His work is included in the collections of the National Museum, Stockholm, Xerox Corporation, Stamford, Connecticut, and Neiman-Marcus, Dallas, Texas.

ANNA BANANA
Anna Banana was born in Victoria, British Columbia, in 1940. She studied at the University of British Columbia at Vancouver, majoring in art and design, and received a B.Ed. in 1967. In 1974, with Bill Gaglione, she founded *Vile* magazine, which features reports on local Dada performances and publishes mail art; also with Gaglione, she conducted a tour of Europe in 1978, visiting eleven countries and conferring "Degrees of Bananalogy." She is active in performance and mail art.

THOMAS BARROW
Thomas Barrow, who lives in Albuquerque, New Mexico, was born in Kansas City, Missouri, in 1938. He received a B.F.A. from the Kansas City Art Institute in 1963, took courses in film at Northwestern University, and received an M.S. in photography from the Illinois Institute of Technology in 1967. Barrow was a staff member of the George Eastman House in Rochester, New York, and also was Assistant Curator of the Research Center. He teaches at the University of New Mexico at Albuquerque.

PATRICK BEILMAN
Born in 1953 in Denver, Colorado, Patrick Beilman studied at the University of Colorado, where he received a B.F.A. in 1975, and did postgraduate study at the School of the Art Institute of Chicago. He has been a guest lecturer at the University of Wisconsin, Milwaukee, Wisconsin, and lives in that city.

WALLACE BERMAN
Wallace Berman was born in Staten Island, New York, in 1926, and attended the Chouinard and the Jepson art schools in Los Angeles. After leaving school, he composed music for Jimmy Witherspoon. In the mid-fifties Berman established *Semina* magazine, and in 1960 opened Semina Gallery, in Los Angeles. He died in California in 1976. A retrospective was held in 1978 at the Whitney Museum of American Art, New York.

JOHN ERIC BROADDUS
John Eric Broaddus studied fine art at the Detroit Society of Arts and Crafts. He has worked as a display artist and set designer, and is noted for his costume exhibitions. He lives in New York City.

CHARLOTTE BROWN
Charlotte Brown studied at Pratt Institute, Brooklyn, New York, where she received a B.F.A. in 1956. She taught at the Art in America School of Painting and was the Art Director for the Woodbury Country Club Association in Woodbury, New York.

GARY BROWN
Gary Brown was born in 1941 at Evansville, Indiana, and lived in New Harmony Colony. He received a B.A. from dePauw University in 1963. After studying in Athens and Florence, he received an M.F.A. from the University of Michigan at Madison. Brown's interests include archaeology and the study of comparative cultures, and papermaking. He is chairman of the art department and professor of painting at the University of California at Santa Barbara.

TAMARA THOMPSON BRYANT
Born in Anderson, Indiana, Tamara Bryant studied at the University of Kentucky at Lexington, where she received a B.A. in art in 1957, and graduated from the University of Indiana at Bloomington with an M.F.A. in 1959. She has been Artist-in-Residence at the University of Kentucky, Lexington, 1965–66, and at Colgate University, Hamilton, New York, 1972–76.

CARIOCA (CARRIE CARLTON)
Carioca was born in 1944 in San Francisco, California. She received a B.A. in painting and sculpture from the University of California at Berkeley in 1966, and did graduate work at San Francisco State University. Carioca founded Apostrophe S, a gallery she managed for several years, and started the Carioca Novelty Company for the design and manufacture of handmade postcards, using color xerography, as part of the New York Correspondence School.

CARL T. CHEW
Born in Urbana, Illinois, in 1948, Carl Chew received a B.S. in zoology in 1973 and an M.F.A. in video and printmaking in 1975 from the University of Washington. His works are in the collections of the Brooklyn Museum, New York, and the University of Washington. He lives in Seattle, Washington.

JUDITH CHRISTENSEN
Born in Sterling, Illinois, in 1939, Judith Christensen studied theater at the University of Iowa, Los Angeles Valley College at Van Nuys, California, and Burghoff Acting Studio, New York, and did off-Broadway and television work. Christensen later studied at California State University, Northridge, and has done photo-sculpture and experimented with nonsilver processes and copying machine technology. She lives in Sherman Oaks, California.

BUSTER CLEVELAND
Buster Cleveland may have been born in Havana, Cuba, in 1943 of American parents. He claims the following central influences on his life as an artist: Robert Motherwell's *Dada Painters and Poets*; the discovery of a Xerox machine in the Boylston Street (Boston) MTA station, which he used to make copy art pieces; and Ray Johnson and the New York Correspondence School. He says that if mankind could accept Dada, the world would be a much nicer place.

DINA DAR
Dina Dar was born in Poland in 1939 and grew up in Israel. She studied with Jean Piaget at the University of Geneva, Switzerland, and then studied painting in Los Angeles at The Art Center and the Otis Art Institute. Her work with xerography began when she copied foods on a Xerox 6500 Color Copier, later using found objects, such as canyon flowers, to produce more fantastic imagery.

MARY J. DOUGHERTY
Mary Dougherty was born in Philadelphia, Pennsylvania, in 1940. She received a B.F.A. in 1975 and an M.F.A. in 1977 from the School of the Art Institute of Chicago, where she taught Generative Systems and was Sonia Sheridan's assistant. Dougherty is a performance artist and believes in involving the audience. She has made an animated film using Haloid Xerox prints; recently returned from a film-making expedition to Guatemala with Peter Thompson, she now administers "Pier Group," a children's art project.

HERB EDWARDS
Herb Edwards was born in Brownsville, Pennsylvania, in 1940. He received a B.F.A. in 1963 from the University of New Mexico at Albuquerque and an M.F.A. in 1969 from Pratt Graphics Institute, New York. He has been teaching at Brookdale Community College, Lincroft, New Jersey, since graduation, and lives in Tinton Falls, New Jersey.

DIEDRE ENGLE
Diedre Engle was born in 1951. She studied at Orange Coast College, Costa Mesa, California, Rochester Institute of Technology, Rochester, New York, and Empire State College, Saratoga Springs, New York, where she received a B.S. in photography in 1977. Engle worked as a freelance photographer, and was a staff photographer at Rochester Institute of Technology. She lives in Fullerton, California.

EVERGON (AL LUNT)
Evergon was born in Niagara Falls, Canada, in 1946. He received a B.F.A. in printmaking from Mount Allison University, Sackville, New Brunswick, in 1970, and an M.F.A. degree in photography from Rochester Institute of Technology, Rochester, New York, in 1974, concentrating on experimental photographic processes. He teaches photography and printmaking at the University of Ottawa, Canada.

WILLIAM FARANCZ
William Farancz has done art direction/production for individuals, businesses, and theater groups, and has designed T-shirts as well as annual reports and television commercials. In 1979, he received the "Desi" award from Graphics USA and Graphics New York. Farancz's work is in the collection of Franklin Furnace, New York. He teaches in New York City.

BERNARD K. FISCHER
Bernard Fischer, who was born in 1947 in Chicago, lives in Chatsworth, California. He is a prominent regional artist and bases much of his work on objects he collects for his antique shop.

DAN FLECKLES
Born in Greenfield, Massachusetts, in 1942, Dan Fleckles graduated from the University of California at Santa Barbara in 1964 with a major in fine arts, studying with Howard Warshaw and Rico Lebrun. In 1969 he received an M.F.A. from the University of Massachusetts, Amherst; after graduation he taught drawing, design, and painting at Kenyon College, Gambier, Ohio. He lives in Gambier.

LELAND FLETCHER
Leland Fletcher was born in Cumberland, Maryland in 1946. He received his undergraduate degree in sculpture from the University of Minnesota, with emphasis in bronze casting and drawing. From 1977 to 1978 Fletcher was a fine arts specialist for the city of San Rafael, California; in that post he coordinated local arts programs and was the curator of several shows. He lives in Lagunitas, California.

CONNIE FOX
Connie Fox was born in Colorado. She studied at the University of Colorado at Boulder, receiving a B.F.A. in 1947; at the Art Center School, Los Angeles; and at the University of New Mexico, Albuquerque, where she received an M.A. She lives in East Hampton, New York.

ANTONIO FRASCONI
Antonio Frasconi was born in 1919 in Montevideo, Uruguay. In New York, he studied at the Art Students League, graduating in 1945, and at the New School of Social Research. Frasconi received a Guggenheim grant in 1953 to illustrate the poetry of Walt Whitman and Garcia Lorca; in 1964, he won the Science Commemorative Stamp competition. His works are included in the Museum of Modern Art, New York, the Fogg Art Museum, Harvard, the Chicago Art Institute, and the Museo Principal de Montevideo. He lives in Norwalk, Connecticut.

DEBORAH FREEDMAN
Born in New York City in 1947, where she now lives, Deborah Freedman received a B.S. in 1970 from New York University, where she studied with Audrey Flack. Her work is included in the collections of Samuel I. Newhouse, Richard and Joanna Koch, IBM Company, and American Telephone and Telegraph, all in New York.

BILL GAGLIONE (DADALAND)
Bill Gaglione was born in 1945 in Queens, New York, and studied at the New York School of Design. In 1969 he moved to the west coast, where he organized the Bay Area Dadaists. Gaglione is interested in performance art and uses his collection of Dada literature as source material. He lives in San Francisco.

LINDA GAMMELL
Linda Gammell received a B.A. from the University of Minnesota in 1972, where she studied photography with Ruth Bernhard, and an M.F.A. in photography in 1978. She received Minnesota State Arts Board Individual Artist grants in 1976 and 1979. Gammell teaches at the "Film in the Cities" program in Minneapolis. Her work is in the collections of the Walker Arts Center and the Minneapolis Institute of Arts. She lives in Minneapolis.

LINTON GODOWN
Linton Godown was born in 1906. He graduated from Ohio State University in 1927, and became an authority on document forgery. Through his professional affiliations Godown began to experiment with the artistic possibilities of the RCA Electrofax system, as well as with prototype models of color copiers. He has conducted wide-ranging experiments with the medium, using combinations of processes to form unique works.

ANDREA GOLDBERG
Andrea Goldberg received a B.F.A. in fine arts in 1976 from the University of Michigan in Ann Arbor. Her films have been shown at the Off-the-Wall Cinema in San Francisco.

CRAIG GOLDWYN
Craig Goldwyn, who lives in Ithaca, New York, graduated in 1972 from the University of Florida at Gainesville. He received a degree in fine arts from the School of the Art Institute of Chicago in 1977, and was one of the first students in the Generative Systems Department founded by Sonia Sheridan. Goldwyn edited *YONY* magazine #4 (the official publication of the Generative Systems Department) and wrote the introduction to *YONY* #5.

ERIN GOODWIN
Born in 1941 in Seattle, Washington, Erin Goodwin received a B.A. from San Jose State College, San Jose, California, and graduated in 1972 with an M.A. in art from California State University at San Jose. From 1974 to 1976, Goodwin was the director of the Helen Euphrat Gallery, San Francisco. She presently teaches printmaking at de Cenza College, Cupertino, California.

WILLIAM GRATWICK
William Gratwick graduated from Harvard College in 1925. He is a sculptor in wood and wax, and has produced a book on his work— "Animal, Vegetable, Womanal." Gratwick's multitude of interests include agriculture, Dorset sheep, carriages, and film-making. He lives in Pavilion, New York.

MARTY GUNSAULLUS
Marty Gunsaullus was born in Chicago, Illinois, in 1946, and lives in Los Angeles, California. He studied illustration, painting, and printmaking at The School of the Art Institute of Chicago, the Layton School of Art, Milwaukee, Wisconsin, and the Kansas City Art Institute, Kansas City, Missouri. Gunsaullus has worked with a variety of photographic processes and done mail art; a rubber stamp he uses reads "The Mailbox is a Museum."

BETTY HAHN
Betty Hahn was born in Chicago, Illinois, in 1940. She graduated from Indiana University in 1963 with a B.A. in design, and received an M.F.A. in photography in 1965; at Indiana, she studied with Henry Holmes Smith. Hahn currently teaches at the University of New Mexico at Albuquerque. Her work is included in the collections of the Museum of Modern Art, New York, the George Eastman House, Rochester, New York, the National Gallery of Canada, Ottawa, and the Smithsonian Institution, Washington, D.C.

KIRSTEN HAWTHORNE
Born in 1949 in Canon City, Colorado, Kirsten Hawthorne attended the University of Colorado at Boulder and the School of the Art Institute of Chicago, where she received an M.F.A. in painting in 1975. Hawthorne writes poetry and is well known for her jewelry. In 1978, she was a color consultant and color xerography technician at Jamie Canvas, SoHo, New York. Her work is included in the collection of the Museum of Modern Art, New York.

WILLIAM GRAY HARRIS
Born in San Francisco in 1948, William Harris received a B.A. in art history from the University of Southern California in 1971. Since graduating, he has worked with videography, photography, and printmaking, and studied film-making with Jordan Belson. He lives in Ojai, California.

ROBERT HEINECKEN
Robert Heinecken was born in 1931 at Denver, Colorado, and received an M.A. in 1960 in painting and printmaking from the University of California at Los Angeles. He has taught at the State University of New York at Buffalo, San Francisco Art Institute, the School of the Art Institute of Chicago, and Harvard University, and is currently teaching at the University of California at Los Angeles. He is a founding member of the Society for Photographic Education.

CAROL HERNANDEZ
Carol Hernandez received a B.F.A. in photography in 1976 from Rochester Institute of Technology, Rochester, New York, where she studied xerography with Charles Arnold. She lives in Los Angeles.

E. F. HIGGINS III
E. F. Higgins III was born in 1949 in New York City. He received a B.A. in fine arts in 1972 from Western Michigan University at Kalamazoo and an M.F.A. from the University of California in 1976. Higgins has worked as a professional lithographer at Scuda Incorporated, Boston, Massachusetts, as an exhibitions installation worker and bartender at Leo Castelli Galleries, New York, and as a color copier operator at Jamie Canvas, SoHo, New York. He is an active participant in the New York Correspondence School of Art.

PATI HILL
Pati Hill was born in Asheville, Kentucky, and attended George Washington University. She was a Powers model, lived in Paris and New York, and published several books of poetry and prose; *Impossible Dreams* was published by Alicejamesbooks in 1976, and her work continues to appear in *The Paris Review*. She lives and works in Paris and Connecticut.

TYLER JAMES HOARE
Born in Missouri in 1940, Tyler James Hoare studied at the University of Colorado Sculpture Center and the University of Kansas, where he graduated with a B.F.A. in painting in 1963; he also studied sculpture at the California College of Arts and Crafts. Hoare conducted a workshop in the 3M color copier process. He uses airplane and automobile motifs in his work.

DOUGLAS HOLLELEY
Douglas Holleley was born in Sydney, Australia, in 1949. He attended Macquarie University in Sydney, and received a B.A. in psychology in 1971. Holleley graduated in 1976 from the Photographic Studies program at the Visual Studies Workshop in Rochester, New York, where he participated in a Generative Systems Workshop given by Sonia Sheridan. He then taught photography in Australia and at Colgate University, Hamilton, New York. In 1978, he married Juliana Swatko; they live in Australia.

SUDA HOUSE
Suda House was born in 1951. She received a B.F.A. in photography and printmaking from the University of Southern California and an M.A. in design and photography from California State University at Fullerton in 1978. House has been a consultant in color copiers to 3M Company, and teaches photography at Southwest College, Los Angeles.

RAY JOHNSON
Born in Detroit, Michigan, in 1927, Ray Johnson studied at the Art Students League, New York, and at Black Mountain College, Black Mountain, North Carolina, where he worked with Josef Albers and Robert Motherwell. Johnson was involved in the Fluxus movement and in Pop Art, and in 1962 he founded the New York Correspondence School. He was given a National Institute of Arts and Letters Award in 1966.

TOD JORGENSEN
Tod Jorgensen lives in New York City. He was born in 1948 in Rockville Centre, New York and received a B.A. in fine arts from the State University of New York at Stony Brook in 1977. Jorgensen manages the color xerography facility at Jamie Canvas Company, SoHo, New York, and has produced correspondence art in the form of postcards, collages, and stamps.

KASOUNDRA
Kasoundra, a person of widely varied interests, lives in New York City. Her professional training was with Joseph Cornell and M. C. Escher. Kasoundra has done commercial illustration; her clothing designs have been used by Frank Zappa, and she has designed jewelry with photographer Benno Freedman. Her activities also include acting in the film "Alice's Restaurant."

TIM KILBY
Born in Charlottesville, Virginia, in 1947, Tim Kilby received a B.S. in industrial art education in 1969 from Virginia Polytechnic Institute. He began graduate work in photography and printmaking in 1976 at Rochester Institute of Technology, Rochester, New York, where he studied with Bea Nettles and Charles Arnold. Kilby teaches photography at Lord Fairfax Community College, Virginia, and lives in Sperryville, Virginia.

ELLEN LAND-WEBER
Ellen Land-Weber was born in Rochester, New York, in 1943. She received a B.A. in 1965 and an M.A. and M.F.A. in 1968 from the University of Iowa, Iowa City. She owns a 3M Color-in-Color machine. Land-Weber was the recipient of a grant from the National Endowment for the Arts to photographers and was one of the photographers included in the Seagram's Bicentennial Court House Project 1975–76. She teaches at Humboldt State University, Arcata, California.

WILLIAM LARSON
Born in 1942 in North Tonawanda, New York, William Larson received a B.S. in art education at the State University of New York at Buffalo in 1964. He studied at the University of Siena, Italy, and in 1966 received an M.S. in photography from the Institute of Design at the Illinois Institute of Technology. Larson teaches at the Tyler School of Art, Philadelphia. His works are in the collections of the Museum of Modern Art, New York, and the Metropolitan Museum of Art, New York.

CAROL LAW
Carol Law was born in 1943. She received an M.F.A. in 1965 from the University of Texas at Austin and an M.A. in 1970 from San Francisco State University. Law also studied at Grafisch Atelier in Amsterdam, Holland. She teaches printmaking at San Francisco State University.

N'IMA LEVETON
N'ima Leveton was born in New York City in 1935 and graduated in 1956 from the University of California at Los Angeles with a B.A. in chemistry. She studied painting with Ruth Asdwa and with Josef Albers at Yale University, New Haven, Connecticut. In 1970 she received an M.A. in fine arts from the San Francisco Art Institute. Leveton now teaches a printmaking/intaglio workshop at the College of the Redwoods, Mendocino, California.

JUDY LEVY

Judy Levy, who lives in Sugar Run, Pennsylvania, studied at Ohio State University, graduating with a B.A. in fine arts in 1960. She also studied printmaking and photography at Pratt Graphics Institute, New York, City College of New York, and the Visual Studies Workshop, Rochester, New York. Levy teaches at Keystone Summer College Art Department in Sugar Run.

JILL LYNNE

Jill Lynne studied fine arts and art education at the State University of New York at New Paltz, where she received a B.S. in 1965 and an M.S. in 1971. She taught at the New School for Social Research, New York, Rutgers University (Livingston College), New Jersey, and the International Center for Photography, New York. Lynne is a founder and director of the Photo-Flow Foundation for Photography and Art, and was the photography coordinator for the National Organization for Women from 1974 to 1976. She lives in New York City.

JOAN LYONS

Joan Lyons was born in 1937 in New York City. She received a B.F.A. from the New York State College of Ceramics at Alfred University in 1957, and in 1973 she received an M.F.A. in photography from the Visual Studies Workshop in Rochester, New York. Lyons did graphic design and printing in New York City and Rochester. She has been teaching at the Visual Studies Workshop since 1972, where she coordinates a print production workshop that produces up to twenty small-edition books a year. Her work is in the collection of the Museum of Modern Art, New York.

MARGARET McGARRITY

Born in 1944, Margaret McGarrity studied at Brown University, Providence, Rhode Island, and photography at Rochester Institute of Technology; she also studied art history at Trinity College, Dublin, Ireland, Yale University, New Haven, Connecticut, and in Siena, Italy. McGarrity has been a lecturer at the Albright-Knox Art Gallery, Buffalo, New York, and the Yale University Art Gallery, and was an associate editor of *Art Gallery* magazine, Ivoryton, Connecticut.

BRUNO MUNARI

Bruno Munari was born in 1907 in Milan, Italy, where he now lives. He began his career as a self-taught artist; today, his work is largely in industrial design, advertising, and visual design research. He has also written innovative books for children. Munari has been instrumental in popularizing the copier as a method of producing art. He conceives of himself as an artist who uses photographic materials, and during his exhibitions he uses a Rank Xerox copier to create art that he then displays to the public.

SIMO NERI

Simo Neri was born in Rome in 1948. She studied philosophy and linguistics at the University of Rome, painting at the Accademia des Belles Artes in Rome, and psychology at Exeter University, Exeter, England. Neri taught English language and culture to Italians and Italian language and culture to Americans. She is now a professional portrait photographer for actors and dancers, and also operates Xerox copy equipment at a copy center. She lives in San Francisco.

ESTA NESBITT

Esta Nesbitt was born in 1918 in New York City, and studied at the Traphagen School, the Pratt Graphics Center, and Columbia University. Nesbitt worked as a fashion illustrator and was a skilled calligrapher. Her experiments with mirrored surfaces led to a process she called "Transcapsa," and her Chromacapsa process introduced color to black-and-white xerography. She died in 1975.

TOM NORTON

Born in 1941 in New York City, Tom Norton received a B.F.A. from the Rhode Island School of Design at Providence. He worked as property manager for the Tyrone Guthrie Theatre, Minneapolis, and a jewelry designer in New York City. Norton is a Research Fellow at the Visible Language Workshop at the Massachusetts Institute of Technology and collaborates with scientist Myron Tribus devising picture-making systems. He owns a 3M Color-in-Color copier.

ANTONIO PETRACCA

Antonio Petracca was born in 1945 in Rochester, New York. He studied and subsequently taught photography at Rochester Institute of Technology, from which he received a B.F.A. in 1967 and an M.F.A. in 1969. He is currently the coordinator of exhibitions and performance at the Pyramid Gallery in Rochester.

SHEILA PINKEL

Sheila Pinkel, who lives in Santa Monica, California, received a B.A. in art from the University of California at Berkeley in 1963 and an M.F.A. in art and photography from the University of California at Los Angeles in 1977. She teaches photography at the University of California at Los Angeles. Her works are in the collections of the Los Angeles County Museum of the Arts, The Museum of Modern Art, New York, and the Fogg Museum, Cambridge, Massachusetts.

LINDA RADEN

Linda Raden was born in Pittsburgh, Pennsylvania in 1951. She received a B.F.A. in sculpture from Washington University, Saint Louis, Missouri, in 1974, and an M.F.A. in sculpture from the University of Ohio, Athens, Ohio, in 1976. Raden's work is inspired by a mathematical construct known as the Fibonacci System, which she believes to be constantly manifest in nature.

SUSIE REED

Susie Reed was born in Denver, Colorado, in 1953, and received a B.F.A. in photography from the San Francisco Art Institute. She teaches xerography at the California College of Arts and Crafts, Valencia, California, and is a freelance designer and illustrator. She lives in San Francisco, California.

DAVID ROOT

David Root was born in 1942 in Saint Paul, Minnesota. He graduated from Rhode Island School of Design with a B.F.A. in 1961, and from 1961 to 1965 studied photography at the Institute of Design, Chicago, Illinois. Root worked as a designer and as an independent design consultant; he has used a Xerox 6500 Color Copier in his design process. His works are in the collection of Xerox Corporation, Leesburg, Virginia.

RACHEL ROSENTHAL

Rachel Rosenthal was born in Paris, France, and attended the High School of Music and Art, New York City, as an art major. She directed and designed off-Broadway productions, and was a member of the Merce Cunningham Dance Company. Her association with Jasper Johns, Robert Rauschenberg, and John Cage and the avant garde of the Parisian Theatre led her to create "Instant Theater." In 1966 Rosenthal returned to the visual arts as a sculptor. She lives in Los Angeles.

WILLYUM ROWE

Born in 1946 in Rockville Centre, Long Island, Willyum Rowe studied illustration at Pratt Institute, where he received a B.F.A. in 1968. He has published a number of books with Dover Press, and the Visual Studies Workshop Press, Rochester, New York, has published two of his artist's books and is planning to publish a set of postcards. Rowe lives in New York City and teaches illustration at the School for Visual Arts.

BETYE SAAR

Betye Saar was born in 1921 at Los Angeles, California, and lives in Laurel Canyon, California. She received a B.A. in design in 1949. Saar teaches drawing and mixed media at the Otis Art Institute, Los Angeles, and has done freelance costume design. She received a National Endowment for the Arts Award in 1974. Her work is in the collections of the San Francisco Museum of Modern Art, the Joseph Hirshhorn collection, and the University of Massachusetts/Amherst.

JEFFREY SCHRIER

Jeffrey Schrier was born in 1943 in Cleveland, Ohio. He studied at the Cleveland Institute of Art and received a B.A. from the California Institute of the Arts, Los Angeles, in 1967. Schrier worked at Walt Disney studios in Burbank, California, at Cambria Studio, West Hollywood, California, and as a fashion illustrator; he began using copiers to duplicate animation illustrations. He is now a freelance illustrator for accounts that include record companies and magazine publishers.

JACQUELINE SHATZ

Born in 1947 in New York City, Jacqueline Shatz studied painting and graphics at the Art Students League, New York, and received a B.F.A. in painting from Hunter College in 1976. She has operated a color copier at Jamie Canvas, SoHo, New York.

SONIA LANDY SHERIDAN

Sonia Sheridan was born in Newark, Ohio. She studied art at Hunter College, and received a B.A. in 1946. Sheridan was Artist-in-Residence at the 3M Color-in-Color research laboratories under the direction of Dr. Douglas Dybvig. She is the founder and director of the Generative Systems Department at The School of the Art Institute of Chicago. In 1973–74, Sheridan received a Guggenheim grant to continue her work with the 3M Color-in-Color copier.

EDMUND SKELLINGS

Edmund Skellings, who has a Ph.D. in English from the University of Iowa, is a nominee for the 1979 Nobel Prize in poetry. He produced the first television program of poetry in 1948, and in 1962 he published *Duets and Duets*, which won the 1962 Chicago/Midwest award in design. These and similar activities have earned Skellings the title "Father of Electronic Poetry." Skellings has also done extensive work in education technology. Using computers and a Xerox 6500 Color Graphics Printer, he has devised a visual method of teaching language structure to children.

BARBARA SMITH

Born in 1931 in Pasadena, California, Barbara Smith studied art at Pomona College, Pomona, California, and received a B.A. in 1953. She received an M.F.A. from the University of California at Irvine in 1971. Her work is in the collections of the Museum of Modern Art, New York, Brooke Alexander, New York, and the Herbert Johnson Museum, Cornell University, Ithaca, New York.

KEITH SMITH

Keith Smith was born in Chicago in 1938. He attended The School of the Art Institute of Chicago, graduating in 1967, and received an M.S. in 1968 from the Institute of Design at the Illinois Institute of Technology. Smith was on the faculty of the Generative Systems Department at The School of the Art Institute of Chicago, and now teaches at the Visual Studies Workshop, Rochester, New York. His works are in the collection of the Museum of Modern Art, New York.

JOEL SWARTZ

Joel Swartz, who lives in Rochester, New York, was born there in 1944. He graduated from Rochester Institute of Technology with a degree in photographic illustration, and received an M.F.A. in the Photographic Studies program offered through the Visual Studies Workshop in Rochester. Swartz initiated the nonsilver processes program at the Workshop; he taught there and at Nazareth College, Rochester, and the University of Rochester.

JULIANA SWATKO

Juliana Swatko was born in 1952 in Syosset, New York. She studied photography with William Larson at the Tyler School of Art, Philadelphia, Pennsylvania, and received a B.F.A. in 1974. Swatko graduated in 1977 from the Photographic Studies program at the Visual Studies Workshop, Rochester, New York, where she participated in a workshop in Generative Systems given by Sonia Sheridan. In 1978 she married Douglas Holleley; they live in Australia.

SARAH TAMOR

Born in 1951, Sarah Tamor received a B.A. in English literature from Barnard College in 1973. She studied drawing and theater at the Feminist Art Studio, Ithaca, New York, and photo-silkscreen with Bes Robinson at the Women's Building, Los Angeles. Tamor was a designer for the Laughing Cat Design Co., Los Angeles, and a freelance photographer and environment designer. She lives in Santa Monica, California.

H. ARTHUR TAUSSIG

H. Arthur Taussig was born in 1941. He received a Ph.D. in biophysics in 1971 from the University of California at Los Angeles. Taussig teaches photography at Orange Coast College, Costa Mesa, California, and is a member of the Society for Photographic Education. His works are in the collections of the Art Institute of Chicago, the Fogg Museum, Cambridge, Massachusetts, and the Los Angeles Center for Photographic Studies.

PETER THOMPSON

Peter Thompson was born in 1945. From 1963 to 1965, he studied classical guitar with Andres Segovia; subsequently, he had a career as a guitarist and lutenist in Europe. He received an M.A. in comparative literature from the University of California at Irvine. Thompson became involved with photography while at the Friends of Photography center in Carmel, California, where he served as curator, exhibition director, and deputy executive director. Most recently, he founded the Generative Systems Department at Columbia College in Chicago.

HELEN WALLIS

Helen Wallis was born in Alhambra, California. She received a B.A. in English from the University of California at Berkeley and an M.F.A. in photography from the University of Florida, where she studied with Jerry Uelsmann. Wallis has taught photography through the University of California at Santa Cruz Extension, Ansel Adams and Friends of Photography workshops, and Cornell University summer school; with two other photographers she opened and operated Gallery 115 in Santa Cruz, California. Her work reflects her interest in dreams, fantasies, and imagination.

STEPHANIE WEBER

Born in Lubbock, Texas, Stephanie Weber received a B.A. in 1963 from the University of California at Los Angeles, majoring in art and studying with Nathan Olivera and Richard Diebenkorn. As a graduate student, she studied with John Paul Jones and Elmer Brischoff at the University of Illinois, receiving an M.F.A. in 1966. Weber is a frequent lecturer, offering a hands-on approach to xerography.

JOHN WOOD

Born in 1922 in Delhi, California, John Wood studied architectural engineering at the University of Colorado and photography and visual design at the Institute of Design of the Illinois Institute of Technology. Since 1955, he has taught ceramics at the College of Ceramics, Alfred University, Alfred, New York, and also teaches at the Visual Studies Workshop, Rochester, New York. His works are in the collections of the International Museum of Photography/George Eastman House, Rochester, National Gallery of Canada, Ottawa, and Museum of Fine Arts, Houston, Texas.

ROB NOAH WYNNE

Rob Noah Wynne was born in New York City in 1948. He majored in fine arts at Pratt Institute, Brooklyn, New York, receiving a B.F.A. in 1970. His work is in the collection and in the lending service of the Museum of Modern Art, New York. He lives in Manhattan.

Opposite page
76. Connie Fox, Tools, 1978.

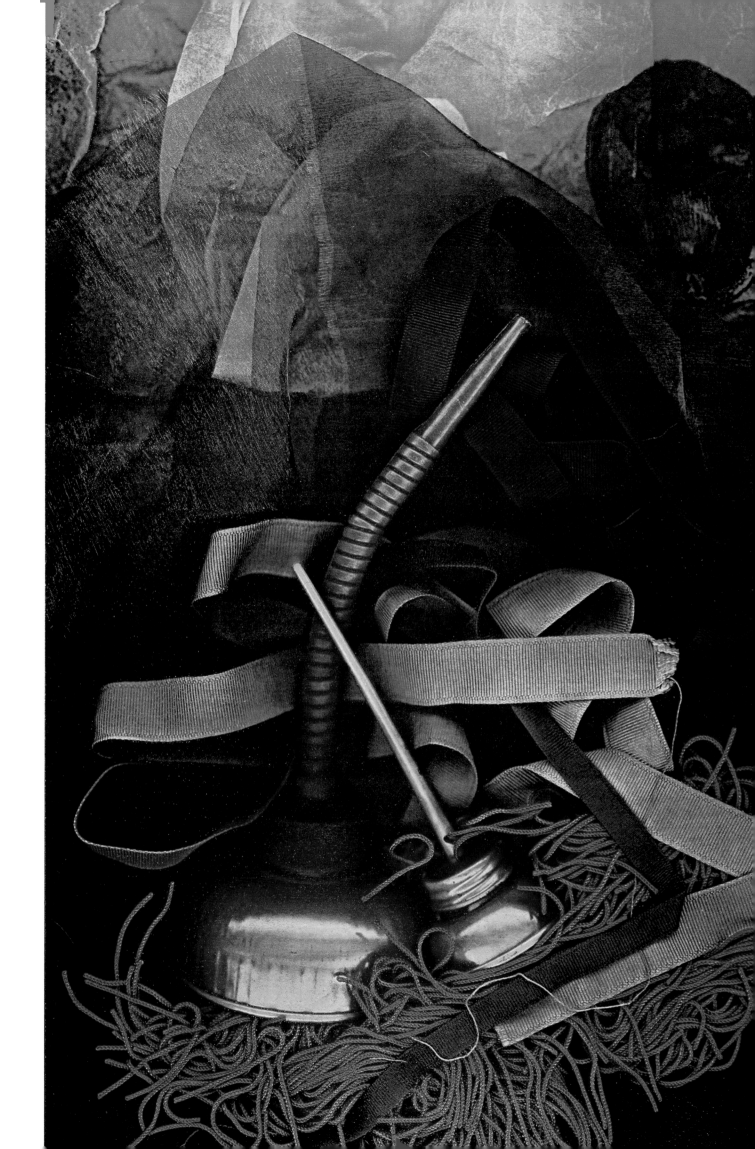

1. Charles Arnold, Jr.
Untitled (Fetish Thing), 1977
Haloid Xerox print
Lent by the artist

2. Charles Arnold, Jr.
Untitled, 1977
Haloid Xerox print
Lent by the artist

3. Charles Arnold, Jr.
Untitled, 1977
Haloid Xerox print
Lent by the artist

4. Charles Arnold, Jr.
Untitled, 1977
Haloid Xerox print
Lent by the artist

5. Charles Arnold, Jr.
Untitled, 1977
Haloid Xerox print
Lent by the artist

6. Thomas Barrow
from artist's book Trivia 2, 1973
Verifax intermediate matrix
Collection IMP/GEH

7. Thomas Barrow
from artist's book Trivia 2, 1973
Verifax intermediate matrix
Collection IMP/GEH

8. Thomas Barrow
from artist's book Trivia 2, 1973
Verifax intermediate matrix
Collection IMP/GEH

9. Thomas Barrow
from artist's book Trivia 2, 1973
Verifax intermediate matrix
Collection IMP/GEH

10. Thomas Barrow
from artist's book Trivia 2, 1973
Verifax intermediate matrix
Collection IMP/GEH

11. Linton Godown
Untitled, 1971
Experimental xerographic print
Lent by the artist

12. Linton Godown
Untitled, 1971
Experimental xerographic print
Lent by the artist

13. Craig Goldwyn
Apples, 1975
APECO liquid toners
on OG Chroma paper
Lent by the artist

14. Craig Goldwyn
Apples, 1975
APECO liquid toners
on OG Chroma paper
Lent by the artist

15. Craig Goldwyn
Apples, 1975
APECO liquid toners
on OG Chroma paper
Lent by the artist

16. Pati Hill
A Swan: an Opera in Nine Chapters, 1978
IBM Copier II print
Lent by the artist

17. Pati Hill
(Untitled) from the series Garments, n.d.
IBM Copier II print
Lent by the artist

18. Pati Hill
(Untitled) from the series Garments, n.d.
IBM Copier II print
Lent by the artist

19. Bruno Munari
Original Xerograph, 1978
Xerox 6500 Color Copier print
Lent by the artist through
Rank Xerox, Milan

20. Bruno Munari
Original Xerograph, 1978
Xerox 6500 Color Copier print
Lent by the artist through
Rank Xerox, Milan

21. Bruno Munari
Original Xerograph, 1970
Rank Xerox 914 print
Lent by the artist through
Rank Xerox, Milan

22. Bruno Munari
Original Xerograph, 1966
Rank Xerox 914 print
Lent by the Museum of Modern Art, NY

23. Bruno Munari
Original Xerograph, 1966
Rank Xerox 914 print
Lent by the Museum of Modern Art, NY

24. Bruno Munari
Original Xerograph, 1966
Rank Xerox 914 print
Lent by the Museum of Modern Art, NY

25. Bruno Munari
Original Xerograph, 1966
Rank Xerox 914 print
Lent by the Museum of Modern Art, NY

26. Bruno Munari
Original Xerograph, 1966
Rank Xerox 914 print
Lent by the Museum of Modern Art, NY

27. Bruno Munari
Original Xerograph, 1977
Xerox 6500 Color Copier print
Lent by the artist through
Rank Xerox, Milan

28. Esta Nesbitt
Chromacapsa, Portrait I (C. Peter
McColough, now Chairman of Xerox
Corporation), 1971
Xerox 3600-III prints
with experimental thermal color toners
Lent by Saul Nesbitt

29. Esta Nesbitt
Transcapsa (Self-Portrait), 1971
Xerographic prints
Lent by Saul Nesbitt

30. Esta Nesbitt
Transcapsa, Untitled, 1971
Xerox 3600-III
Lent by Saul Nesbitt

31. Esta Nesbitt
Little Big Eyes Wave, 1972
Xerographic prints
Lent by Saul Nesbitt

32. Tom Norton
Electrographic Figure, 1978
3M Color-In-Color print
Lent by the artist

33. Tom Norton
Electrographic Figure, 1978
3M Color-In-Color print
Lent by the artist

34. Sonia Landy Sheridan
Hand With Hearts, 1976
3M Color-In-Color I prints
Lent by the artist

35. Sonia Landy Sheridan
Al Button's Dye Gloves, 1970
3M Color-In-Color print
Lent by the artist

36. Sonia Landy Sheridan
Hand, 1970
3M Color-In-Color print powder
on 3M VQC paper
Lent by the artist

37. Sonia Landy Sheridan
Pressed Plant, 1976
3M Thermo-Fax
Lent by the artist

38. Sonia Landy Sheridan
Pressed Plant, 1976
3M B systems paper
Lent by the artist

39. Sonia Landy Sheridan
Flowers, 1976
3M Color-In-Color Computer print
Lent by the artist

40. Sonia Landy Sheridan
 Flowers, 1976
 3M Color-In-Color Computer print
 Lent by the artist

41. Sonia Landy Sheridan
 Flowers, 1976
 3M Color-In-Color Computer print
 Lent by the artist

42. Sonia Landy Sheridan
 Flowers, 1976
 3M Color-In-Color Computer print
 Lent by the artist

43. Sonia Landy Sheridan
 Robert Gundlach, 1977
 Haloid Xerox print
 Lent by the artist

44. Sonia Landy Sheridan
 Scientist's Hand, 1976
 3M VRC (telecommunications
 equipment) print
 Lent by the artist

45. Sonia Landy Sheridan
 People's Fabric Test, 1974
 3M VRC (telecommunications
 equipment), Color-In-Color
 Lent by the artist

46. Sonia Landy Sheridan
 People's Fabric Test, 1974
 3M VRC (telecommunications
 equipment), Color-In-Color
 Lent by the artist

47. Sonia Landy Sheridan
 Sonia in Time, 1974
 3M VQC I print
 Color-In-Color powder
 Lent by the artist

48. Sonia Landy Sheridan
 Sonia In The Electric Garden, 1974
 3M VQC I print
 Color-In-Color powder
 Lent by the artist

49. Sonia Landy Sheridan
 Sonia Through the Planet, 1974
 3M VQC I print
 Color-In-Color powder
 Lent by the artist

50. Sonia Landy Sheridan
 Sonia Through Marilyn Goldstein, 1974
 3M VQC I print
 Color-In-Color powder
 Lent by the artist

51. Sonia Landy Sheridan
 Nathan, 1972
 3M Color-In-Color I,
 Color-In-Color II prints
 Lent by the artist

52. Sonia Landy Sheridan
 Shelley & Ken, 1972
 Haloid Xerox print on fabric
 Lent by the artist

53. Sonia Landy Sheridan
 Jim in the Cabin He Built, 1977
 Haloid Xerox print
 Lent by the artist

54. Sonia Landy Sheridan
 Sonia, 1971
 3M Color-In-Color I print
 Lent by the artist

55. Sonia Landy Sheridan
 Soap Opera Lady, 1974
 3M Color-In-Color I print
 from video signal
 Lent by the artist

56. Sonia Landy Sheridan
 Malu at the Museum of Science and
 Industry, 1978
 Haloid Xerox and
 3M Color-In-Color I print
 Lent by the artist

57. Sonia Landy Sheridan
 Douglas Dybvig, 1970
 3M Color-In-Color I print
 Lent by the artist

58. Sonia Landy Sheridan
 Think No Evil, 1972
 Haloid Xerox print with colored ink
 Lent by the artist

59. Keith Smith
 Brian, 1973
 Verifax print
 Lent by the artist

60. Keith Smith
 Untitled, 1971
 Color-In-Color print matrix
 Lent by the artist

61. Keith Smith
 Brian and Roja, South Laguna,
 Christmas 1972, 1973
 Verifax print
 Lent by the artist

62. Keith Smith
 Brian Playing with Roja near the
 Date Shake Shop, 1973
 Verifax print
 Lent by the artist

63. Keith Smith
 Untitled, 1973
 Verifax print
 Lent by the artist

64. Joel Swartz
 from the series Downtown, 1975
 Haloid Xerox print
 Lent by the artist

65. Joel Swartz
 from the series Downtown, 1975
 Haloid Xerox print
 Lent by the artist

66. Barbara Astman
 Plastic Flowers: Roses #1, 1976
 Xerox 6500 Color Copier prints
 Heat transfer to paper
 Lent by the artist

67. Judith Christensen
 Beyond Limitations, 1979
 Xerox 6500 Color Copier print
 Lent by the artist

68. Judith Christensen
 Evolution Series #5, 1978
 Xerox 6500 Color Copier print
 Lent by the artist

69. Buster Cleveland
 Cavellini Beer, 1978
 Xerox 6500 Color Copier print
 Lent by the artist

70. Dina Dar
 Metamorphosis, 1978
 Xerox 6500 Color Copier prints
 Lent by the artist

71. Dina Dar
 Slow Boat to China, 1978
 Xerox 6500 Color Copier prints
 Lent by the artist

72. Dina Dar
 One Bird Left, 1978
 Xerox 6500 Color Copier print
 Lent by the artist

73. Dina Dar
 The Goat Bride, 1979
 Xerox 6500 Color Copier prints
 Lent by the artist

74. Connie Fox
 Tiny Pitchfork, 1978
 Xerox 6500 Color Copier print
 Lent by the artist

75. Connie Fox
 Pliers, 1978
 Xerox 6500 Color Copier print
 Lent by the artist

76. Connie Fox
 Oil Cans, 1978
 Xerox 6500 Color Copier print
 Lent by the artist

77. Connie Fox
Glass Tools with Confetti, 1978
Xerox 6500 Color Copier print
Lent by the artist through Far Gallery

78. Connie Fox
Whisk Broom, 1978
Xerox 6500 Color Copier print
Lent by the artist

79. Connie Fox
Glass Tools with Multicolored
Ribbons, 1978
Xerox 6500 Color Copier print
Lent by the artist

80. Erin Goodwin
Magician Series: Magic Trick, 1979
Xerox 6500 Color Copier print
Lent by the artist through
Jehu Gallery, Inc.

81. Erin Goodwin
Magician Series: Rosie's Baby, 1979
Xerox 6500 Color Copier print
Lent by the artist through
Jehu Gallery, Inc.

82. Erin Goodwin
Magician Series: Special Eggs, 1979
Xerox 6500 Color Copier print
Lent by the artist through
Jehu Gallery, Inc.

83. William Gray Harris
Hand Jive, 1973
3M Color-In-Color print
Lent by the artist

84. Carol Hernandez
Bananas, 1977
Haloid Xerox print
Lent by the artist

85. Douglas Holleley
from The Ray Gun Catalogue, 1976
Xerox 6500 Color Copier prints
Lent by the artist

86. Suda House
Lasagna Recipe, 1978
Xerox 6500 Color Copier print
Lent by the artist

87. David Root
(Untitled) from the series Food, 1976
Xerox 6500 Color Copier print
Lent by the artist

88. David Root
(Untitled) from the series Food, 1976
Xerox 6500 Color Copier print
Lent by the artist

89. David Root
(Untitled) from the series Food, 1976
Xerox 6500 Color Copier print
Lent by the artist

90. Jacqueline Shatz
Horseshoe Crab and Plastic Flower, 1978
Xerox 6500 Color Copier print
Lent by the artist

91. Jacqueline Shatz
Egg and Plastic Flower, 1978
Xerox 6500 Color Copier print
Lent by the artist

92. Sarah Tamor
Gravity Series: Pink Scarf, 1979
Xerox 6500 Color Copier prints
Lent by the artist

93. Sarah Tamor
Gravity Series: Green Scarf, 1979
Xerox 6500 Color Copier prints
Lent by the artist

94. William Gray Harris
Self Portrait, 1973
3M Color-In-Color print
Lent by the artist

95. N'ima Leveton
He Looks, She Smiles, 1969
Xerographic prints
Lent by the artist

96. Joan Lyons
Untitled (self-portrait), 1974
Offset lithograph from
Haloid Xerox masters
Lent by the artist through
Visual Studies Workshop Gallery

97. Joan Lyons
Untitled (Woman with hair), 1974
Offset lithograph from
Haloid Xerox masters
Lent by the artist through
Visual Studies Workshop Gallery

98. Antonio Petracca
Mike Aquilina from Gurning &
Flexing Contest, n.d.
Xerographic print
Lent by the artist

99. Antonio Petracca
Jose Luis Suro from Gurning &
Flexing Contest, n.d.
Xerographic print
Lent by the artist

100. Barbara Astman
Gray and the Seven Sacraments, 1976–77
Xerox 6500 Color Copier prints
Heat transfer to paper
Lent by the artist

101. Anna Banana
Geneva with Anna Banana &
G. A. Cavellini, 1979
Xerox 6500 Color Copier prints
Lent by the artist

102. Anna Banana
The Piazzetta with Anna Banana &
G. A. Cavellini, 1979
Xerox 6500 Color Copier prints
Lent by the artist

103. Patrick Beilman
Cow Town Art: Bullcum Series, 1979
Xerox 6500 Color Copier print
Lent by the artist

104. Patrick Beilman
Cow Town Art: Beef Stew, 1979
Xerox 6500 Color Copier print
Lent by the artist

105. Tamara Thompson Bryant
Goodbyes #19:
Series #5 + #5 + #5 + #5, 1979
Xerox 6500 Color Copier prints
Lent by the artist

106. Tamara Thompson Bryant
Goodbyes #16: Series #2 × #2, 1979
Xerox 6500 Color Copier prints
Lent by the artist

107. Tamara Thompson Bryant
Goodbyes #11: Series #2 + #2, 1979
Xerox 6500 Color Copier prints
Lent by the artist

108. Tamara Thompson Bryant
Goodbyes #4: Series #4, 1979
Xerox 6500 Color Copier prints
Lent by the artist

109. Carl T. Chew
Prodigious Mastodon, 1977
Xerox 6500 Color Copier print
Lent by the artist

110. Carl T. Chew
C. T. Chew Eats Stamp, 1978
Xerox 6500 Color Copier print
Lent by the artist

111. Carl T. Chew
George Eastman Hunting Elephant
with Stamp, 1979
Xerox 6500 Color Copier print
Lent by the artist

112. Buster Cleveland
Visual Poem #13, 1978
Xerox 6500 Color Copier print
Lent by the artist

113. Buster Cleveland
Visual Poem #1, 1977
Xerox 6500 Color Copier print
Lent by the artist

114. Buster Cleveland
Visual Poem for a Kool Life, 1978
Xerox 6500 Color Copier print
Lent by the artist

115. Buster Cleveland
OK Post: Cavellini, 1978
Xerox 6500 Color Copier print
Lent by the artist

116. Evergon
Untitled, 1978
Xerox 6500 Color Copier print
Lent by the artist

117. Evergon
Sweet Willyum, 1979
Xerox 6500 Color Copier print
Lent by the artist

118. Evergon
(Untitled) for Canada Portfolio, 1978
Xerox 6500 Color Copier print
Lent by the artist

119. Evergon
Untitled, 1979
Xerox 6500 Color Copier print
Lent by the artist

120. Evergon
Untitled, 1979
Xerox 6500 Color Copier print
Lent by the artist

121. Evergon
Untitled, 1976
Xerox 6500 Color Copier print
Lent by the artist

122. William Farancz
Untitled, 1978
Xerox 6500 Color Copier print
Lent by the artist

123. William Farancz
Untitled, 1978
Xerox 6500 Color Copier print
Lent by the artist

124. Antonio Frasconi
Monet at Giverny III, 1979
Xerox 6500 Color Copier prints
Heat transfer to paper
Lent by the artist

125. Antonio Frasconi
Monet at Giverny V, 1979
Xerox 6500 Color Copier prints
Heat transfer to paper
Lent by the artist

126. Bill Gaglione (Dadaland)
Untitled, 1979
Xerographic print
Lent by the artist

127. Bill Gaglione (Dadaland)
(Untitled) A-9, 1979
Xerographic print
Lent by the artist

128. Linda Gammell
Untitled, 1978
Xerox 6500 Color Copier print
Heat transfer to paper
Lent by the artist

129. Linda Gammell
Untitled, 1978
Xerox 6500 Color Copier print
Heat transfer to paper
Lent by the artist

130. William Gratwick
Nimbus, 1978
IBM Copier II print
Lent by the artist

131. William Gratwick
Untitled, 1978
IBM Copier II print
Lent by the artist

132. Marty Gunsaullus
Untitled, 1979
Xerox 6500 Color Copier print
Lent by the artist

133. Marty Gunsaullus
Untitled, 1979
Xerox 6500 Color Copier print
Lent by the artist

134. William Gray Harris
Path of Enlightenment, 1973
3M Color-in-Color print
Lent by the artist

135. William Gray Harris
Universal City, 1973
3M Color-in-Color print
Lent by the artist

136. William Gray Harris
Mystic Vision, 1973
3M Color-in-Color print
Lent by the artist

137. E. F. Higgins III
Pyramid Series: Doo-Da Postage
Works, 1979
Xerox 6500 Color Copier print
Lent by the artist

138. E. F. Higgins III
Anna Banana Commemorative, 1979
Xerox 6500 Color Copier print
Lent by the artist

139. E. F. Higgins III
Famous Art Series: Doo-Da Post, 1978
Xerox 6500 Color Copier print
Lent by the artist

140. E. F. Higgins III
Pyramid Issue: Doo-Da Postage
Works, 1978
Xerox 6500 Color Copier print
Lent by the artist

141. Ray Johnson
Untitled, 1978
Minolta Copier print
Lent by the artist

142. Ray Johnson
Untitled, 1978
Minolta Copier print
Lent by the artist

143. Ray Johnson
Untitled, 1979
Minolta Copier print
Lent by the artist

144. Kasoundra
Optical Maze, 1977
Xerox 6500 Color Copier print
Lent by the artist

145. Kasoundra
Pinball Parrot, 1977
Xerox 6500 Color Copier print
Lent by the artist

146. Carol Law
White House Women, 1976
Xerox 6500 Color Copier prints
Lent by the artist through
Jehu Gallery, Inc.

147. Jill Lynne
SpaceScape: From One Planet to
Another—Earth To The Moon, 1978
Xerox 6500 Color Copier prints
Heat transfer to paper
Lent by the artist

148. Jill Lynne
SpaceScape: Flying—Over Earthviews
From The Moon, 1978
Xerox 6500 Color Copier prints
Heat transfer to paper
Lent by the artist

149. Willyum Rowe
Reunion/Motel Room Stamps:
Series A, #4, 1979
Xerox 6500 Color Copier print
Lent by the artist

150. Willyum Rowe
Insanity in America: Sketch Book
Volume I, Xerox Edition Two, Page
Number 101, 1975
Xerox 6500 Color Copier print
Lent by the artist

151. Willyum Rowe
Reunion/Motel Room Stamps:
Series A, #10, 1979
Xerox 6500 Color Copier print
Lent by the artist

152. Willyum Rowe
Insanity in America: Sketch Book
Volume I, Xerox Edition Two, Page
Number 94, 1975
Xerox 6500 Color Copier print
Lent by the artist

153. Willyum Rowe
Insanity in America: Sketch Book
Volume I, Xerox Edition Two, Page
Number 100, 1975
Xerox 6500 Color Copier print
Lent by the artist

154. Willyum Rowe
Insanity in America: Sketch Book
Volume I, Xerox Edition Two, Page
Number 93, 1975
Xerox 6500 Color Copier print
Lent by the artist

155. Willyum Rowe
(Rosebuds) Sketch Book Volume I,
Xerox Edition Two, Page Number 253,
1976
Xerox 6500 Color Copier print
Lent by the artist

156. Willyum Rowe
(Rosebuds) Sketch Book Volume I,
Xerox Edition Two, Page Number 255,
1976
Xerox 6500 Color Copier print
Lent by the artist

157. Jeffrey Schrier
Embryo Ahead of its Time, 1979
Xerox 6500 Color Copier prints
Collage
Lent by the artist

158. Jeffrey Schrier
Quest for Energy, 1978
Xerox 6500 Color Copier prints
Collage
Lent by the artist

159. Juliana Swatko
Untitled, 1979
Haloid Xerox print
Lent by the artist

160. Juliana Swatko
Untitled, 1979
Haloid Xerox print
Lent by the artist

161. H. Arthur Taussig
The Three Horsemen of the
Apocalypse, 1972
3M Color-in-Color print
Lent by the artist

162. H. Arthur Taussig
Night Train to Valhalla, 1972
3M Color-in-Color print
Lent by the artist

163. H. Arthur Taussig
Picnic for a Camel Mile, 1972
3M Color-in-Color print
Lent by the artist

164. Helen Wallis
Gertrude Stein Series #5, 1976
Xerox 6500 Color Copier print
Lent by the artist

165. Helen Wallis
Gertrude Stein Series #1, 1976
Xerox 6500 Color Copier print
Lent by the artist

166. Patricia Ambrogi
Xerox Cloud, 1979
Haloid Xerox print
from video signal
Lent by the artist

167. Peter Astrom
Lollipops, 1979
Xerox 6500 Color Copier prints
Heat transfer to paper, applied color
Lent by the artist

168. Peter Astrom
Bent Flowers, 1979
Xerox 6500 Color Copier prints
Heat transfer to paper, applied color
Lent by the artist

169. Peter Astrom
Composition of Flowers, 1978
Xerox 6500 Color Copier prints
Heat transfer to paper, applied color
Lent by the artist

170. Wallace Berman
Untitled, n.d.
Verifax print
Lent by L. A. Louver Gallery

171. Wallace Berman
Untitled, n.d.
Verifax print
Lent by L. A. Louver Gallery

172. Charlotte Brown
Hand Made Paper Stack with Rope, 1979
3M Color-In-Color print
Heat transfer to paper
Lent by the artist

173. Charlotte Brown
Fragments, 1979
3M Color-In-Color print
Heat transfer to paper
Lent by the artist

174. Dan Fleckles
Untitled, 1978
Xerox 6500 Color Copier print
Heat transfer to paper
Lent by the artist

175. Dan Fleckles
Untitled, 1978
Xerox 6500 Color Copier print
Heat transfer to paper
Lent by the artist

176. Deborah Freedman
Moriches Shift III, 1978
Xerox 6500 Color Copier print
Collage
Lent by the artist

177. Robert Heinecken
Cliche Vary/Fetishism, 1975
Offset lithograph from
3M Color-In-Color intermediate
Lent by the artist

178. Tod Jorgensen
Untitled, 1979
Xerox 6500 Color Copier print
Lent by the artist

179. Ellen Land-Weber
Untitled: Algae Series, 1979
3M Color-In-Color prints
Heat transfer to paper
Lent by the artist

180. Ellen Land-Weber
Untitled: Algae Series, 1978
3M Color-In-Color prints
Heat transfer to paper
Lent by the artist

181. William Larson
Untitled, 1976
Telecommunications equipment print
Lent by the artist

182. William Larson
Untitled, 1976
Telecommunications equipment print
Lent by the artist

183. Joan Lyons
Untitled: Xerox Drawing, 1978
Haloid Xerox print with applied color
Lent by the artist through
Visual Studies Workshop Gallery

184. Joan Lyons
Untitled: Xerox Drawing, 1978
Haloid Xerox print with applied color
Lent by the artist through
Visual Studies Workshop Gallery

185. Margaret McGarrity
Untitled, 1977
Haloid Xerox print
Lent by the artist

186. Margaret McGarrity
Untitled, 1977
Haloid Xerox print
Lent by the artist

187. Margaret McGarrity
Untitled, 1977
Haloid Xerox print
Lent by the artist

188. Margaret McGarrity
Untitled, 1976
Haloid Xerox print
Lent by the artist

189. Susie Reed
Feels Like Me, n.d.
Xerox 6500 Color Copier print
Collage
Lent by the artist

190. Susie Reed
Circlin' Marbles, **n.d.**
Xerox 6500 Color Copier print
Collage
Lent by the artist

191. Betye Saar
Tattoo, 6-76, 1979
Xerox 6500 Color Copier print
One of ten from the portfolio Personal
Papers: Visible/Invisible
Lent by the artist

192. Betye Saar
Lake Piru, 2-78, 1978
Xerox 6500 Color Copier print
One of ten from the portfolio Personal
Papers: Visible/Invisible
Lent by the artist

193. Barbara Smith
Untitled, 1964
Xerographic prints with Plexiglas
Lent by the artist

194. Peter Thompson
Untitled, n.d.
Telecommunications equipment print
Lent by the artist

195. Peter Thompson
Untitled, n.d.
Telecommunications equipment print
Lent by the artist

196. Stephanie Weber
Layers & Veils, 1978
Xerox 6500 Color Copier prints
and mixed media
Lent by the artist

197. Stephanie Weber
Pages from the Shaman's Journal, 1978
Xerox 6500 Color Copier prints
and mixed media
Lent by the artist

198. John Wood
Untitled, n.d.
Xerographic print with pencil
Lent by the artist

199. John Wood
Untitled, n.d.
Xerographic print with pencil
Lent by the artist

200. Rob Noah Wynne
Untitled, 1975
Xerox 6500 Color Copier print
with gelatin silver print
Lent by the artist

201. Barbara Astman
Untitled: Presents & things . . ., 1977
Xerox 6500 Color Copier prints
Heat transfer to paper
Lent by the artist

202. Barbara Astman
Designer T-Shirt: Schantz, 1976
Xerox 6500 Color Copier print
Heat transfer to fabric, Polacolor prints
Lent by the artist

203. Barbara Astman
Designer T-Shirt: Wallace, 1976
Xerox 6500 Color Copier print
Heat transfer to fabric, Polacolor prints
Lent by the artist

204. John Eric Broaddus
The Sorcerer, 1978
Kodak Ektaprints
Lent by the artist through
Marilyn Lev Gallery

205. Gary Brown
Hand Job, 1974
3M Color-In-Color matrix, mixed media
Lent by the artist

206. Carioca (Carrie Carlton)
Foot Fetish, 1979
Xerox 6500 Color Copier prints
Heat transfer to fabric, mixed media
Lent by the artist

207. Carioca (Carrie Carlton)
Biggest in the World (Part II), 1979
Xerox 6500 Color Copier print
Lent by the artist

208. Carioca (Carrie Carlton)
Untitled, 1977
Xerox 6500 Color Copier print
Lent by the artist

209. Carioca (Carrie Carlton)
Under Wraps, 1979
Xerox 6500 Color Copier print
Lent by the artist

210. Carioca (Carrie Carlton)
S. I. Hayakawa, 1977
Xerox 6500 Color Copier print
Lent by the artist

211. Carioca (Carrie Carlton)
Untitled, 1977
Xerox 6500 Color Copier print
Lent by the artist

212. Carioca (Carrie Carlton)
Untitled, 1977
Xerox 6500 Color Copier print
Lent by the artist

213. Carioca (Carrie Carlton)
Ingres Backpacker, 1977
Xerox 6500 Color Copier print
Lent by the artist

214. Carioca (Carrie Carlton)
Untitled, 1979
Xerox 6500 Color Copier print
Lent by the artist

215. Carioca (Carrie Carlton)
Untitled, 1977
Xerox 6500 Color Copier print
Lent by the artist

216. Carioca (Carrie Carlton)
Lava Lamps, 1979
Xerox 6500 Color Copier print
Lent by the artist

217. Mary J. Dougherty
Transference, n.d.
Haloid Xerox prints
with 3M Color-In-Color dyes
Lent by the artist

218. Mary J. Dougherty
Chicago: Bound for New York,
November 21, 1978
Xerographic prints
Lent by the artist

219. Herb Edwards
Tea for Two, 1976
3M Color-In-Color print
Heat transfer to fabric, mixed media
Lent by the artist

220. Diedre Engle
Quilt, 1977–78
Xerox 6500 Color Copier prints
Heat transfer to fabric, mixed media
Lent by the artist

221. Diedre Engle
Untitled, 1978
Xerox 6500 Color Copier print
Heat transfer to fabric, mixed media
Lent by the artist

222. Diedre Engle
Poolside, 1978–79
Xerox 6500 Color Copier print
Heat transfer to fabric, mixed media
Lent by the artist

223. Bernard K. Fischer
Snapshots, 1977–78
Xerox 6500 Color Copier prints
Lent by the artist

224. Leland Fletcher
American Exchange, 1977
Xerox 6500 Color Copier prints
Lent by the artist

225. Andrea Goldberg
Shopping Bag, 1979
Xerox 6500 Color Copier print
Heat transfer to fabric, mixed media
Lent by the artist

226. Betty Hahn
Soft Daguerreotype, 1973
Haloid Xerox print
on fabric, mixed media
Collection IMP/GEH

227. Kirsten Hawthorne
Found Masks, 1975–78
Xerox 6500 Color Copier prints
Lent by the artist

228. Kirsten Hawthorne
Xerox Jewelry (necklace), 1978
Xerox 6500 Color Copier prints
on transparency material, mixed media
Lent by the artist

229. Kirsten Hawthorne
Postcards, 1979
Xerox 6500 Color Copier prints
Heat transfer to paper
Lent anonymously

230. Kirsten Hawthorne
Xerox Jewelry (pins), 1978
Xerox 6500 Color Copier prints
on transparency material, mixed media
Lent by the artist

231. Kirsten Hawthorne
Xerox Jewelry (bracelets), 1978
Xerox 6500 Color Copier prints
on transparency material, mixed media
Lent by the artist

232. Carol Hernandez
Bananas, 1976
Haloid Xerox print on printing plate
Lent by the artist

233. Tyler James Hoare
Xerox Car, 1976
Xerox 6500 Color Copier prints,
mixed media
Lent by the artist

234. Tyler James Hoare
Classic, 1976
Xerox 6500 Color Copier prints,
mixed media
Lent by the artist

235. Suda House
Striptease #3, 1975
3M Color-In-Color prints
Heat transfer to fabric, mixed media
Lent by the artist

236. Suda House
What's a woman to do . . ., 1979
Xerox 6500 Color Copier prints
Heat transfer to fabric, mixed media
Lent by the artist

237. Tim Kilby
Untitled: TV Guide, 1977
Xerox 6500 Color Copier prints
Lent by the artist

238. Judy Levy
Telling Time, 1979
Offset lithographs from
Haloid Xerox masters
Lent by the artist

239. Simo Neri
Flagpoles, 1978
Xerox 6500 Color Copier prints
Heat transfer to fabric
Lent by the artist

240. Sheila Pinkel
Untitled, n.d.
Xeroradiograph
Lent by the artist

241. Linda Raden
Counting, 1979
Xerox 6500 Color Copier prints
Lent by the artist

242. Rachel Rosenthal
Petit-Beurre: An Autobiography, 1978
Xerox 6500 Color Copier prints
Lent by the artist

243. Edmund Skellings
Colorpoems, 1979
Xerox 6500 Color Graphics Printer
from Tektronics computer terminal
Lent by the artist

244. Barbara Smith
Untitled, n.d.
Xerographic prints
Lent by the artist

245. Barbara Smith
Untitled, n.d.
Xerographic prints
Lent by the artist

Tracing the evolution of ideas and contributions that comprise an exhibition and its catalogue is a difficult—almost impossible—task. Exhibitions are born out of the efforts of many people, numerous conversations, letters, books, and hours of looking at works of art. They encompass many individual perspectives and can change direction as well as shape many times before the public enters the gallery on opening night. This exhibition certainly is no different.

ELECTROWORKS grew from an experience in the library at Arizona State University in 1969, when a few friends and I discovered that the coin-operated copier could create new materials for collage and transform our drawings and photographs. In the intervening years, Madeline Averette, Karen Stone, and Don Peterson introduced many copier concepts to me through their work.

The most obvious debt of gratitude is owed to all of the artists who have allowed me to see their work, answered questions, and supplied information that helped to determine the scope of the exhibition.

I am deeply indebted to Xerox Corporation for its generous support of the many aspects of ELECTROWORKS. The role of the corporate patron in the arts is well established; the role of Xerox in this exhibition, however, is special. The participation of Xerox marks a departure from the traditional corporate sponsorship of the historically oriented blockbuster exhibitions and provides the unique opportunity to study the critical issues of and identify the significant contributors to this contemporary art phenomenon. Most important, this exhibition serves as an acknowledgement of the artist's unique contributions to our technological age, and as a testimony to the encouragement of contemporary artists and their activities by business and industry.

Several individuals from Xerox who have made personal contributions to ELECTROWORKS deserve special mention. Theresa Schneder's encouragement and initial interest in the project helped to make ELECTROWORKS a reality. I would also like to thank Harold Davis, Dr. Joseph Cahalan, and Edward Truschke. Special thanks go to Elizabeth Kucklick for her friendship and interest in the daily changes of the project. I am most grateful to Robert Schneider for his support and confidence. Harold Bogdonoff, George Carr, Terry Dillman, Robert Gundlach, Alan Morganstein, John Rasor, Peter Waasdorp, and Arthur Zuckerman have all generously contributed their time. Ken Powell and Spencer Welch of IBM and Donald Conlin, Dr. Douglas Dybvig, Don Gahlon, and Dr. Carl Miller of 3M Company have also contributed historical and technical information.

Special contributions that helped shape the exhibition were made by three unique individuals. In acknowledgement of a special debt, I thank Sonia Landy Sheridan for her invaluable contributions of source material and pervasive critical perspective. Discussions with Bill Jenkins, formerly the Assistant Curator of Twentieth-Century Photography at the International Museum of Photography/George Eastman House, helped me to establish a personal perspective. Robert Sobieszek, Curator of Nineteenth-Century Photography at IMP/GEH, has been both mentor and colleague.

The production of the catalogue and the exhibition required the involvement of many talented people. I particularly thank Volker Hausin, the art director, for seeing us through it all. His organizational ability and sense of humor proved as important as his skills as a designer. Ceil Goldman edited and proofread the text and I am thankful for her unrelenting attention to even the smallest details. Special appreciation goes to Jill Stolt, who provided design and production assistance. The staff of Great Lakes Press deserves special recognition for contributing significantly to the appearance of this catalogue. I also thank Dick Davis for his interest.

I particularly wish to acknowledge the contributions of Robert J. Doherty, Director of IMP/GEH, and the staff of IMP/GEH: Andrew Eskind, Marianne Margolis, Christine Hawrylak, Lee Norton, Roger Bruce, Dan Meyers, Jeff Wolin, Linda McCausland, and Rick Hock, with special appreciation to my assistant, Maria Harper, who brought order to the chaos and corrected my spelling. Joseph Arkins was invaluable in compiling the biographical material for the catalogue, and Jay Pastelak, Margaret Belisle, Patricia Ambrogi, and Chris Phillips all provided indispensable help.

Many other people provided support: Alexandra Anderson, Douglas Davis, Charles Desmarais, Tom Dickey, Kris DiLorenzo, Kenneth Friedman, Patrick Firpo, Nancy Hall-Duncan, Julie Hartenstein, Ken Hansen, Marka Hitt, Joyce Herman, Judith Hoffberg, Linda Holmes, Laurel Huggins, Claudia Katayanagi, Diane Kirkpatrick, Joan Lyons, Cheryl Short, Ted Swigon, Ruth Westfall, Fred and Elaine Yapelli—all deserve special thanks.

Most of all I thank my son, Jonathan, for accepting a mother who is always going to the airport or typing in the attic.

Marilyn McCray